SKIING IN
MASSACHUSETTS

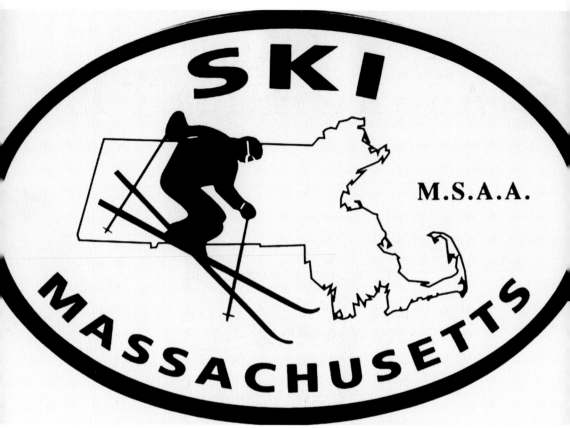

The 2006 logo of the Massachusetts Ski Areas Association promotes skiing in the state. (Courtesy New England Ski Museum.)

On the front cover: Superimposed on the background is the double chair built in 1961 at Mount Tom, Holyoke. Mount Tom as a ski area no longer exists. (Courtesy Cal Conniff.)

On the back cover: Please see page 58. (Courtesy Cal Conniff.)

Cover background: This is Bousquet's in its 1930s glory days. Bousquet's is now a year-round resort. (Courtesy Paul Bousquet.)

SKIING IN MASSACHUSETTS

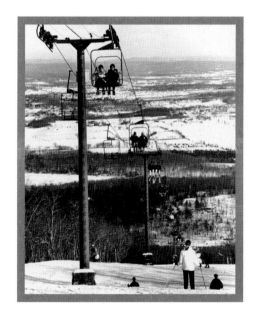

Cal Conniff and E. John B. Allen

ARCADIA
PUBLISHING

Published by Arcadia Publishing
Charleston SC, Chicago IL, Portsmouth NH, San Francisco CA

Printed in the United States of America

Library of Congress Catalog Card Number: 2006926353

For all general information contact Arcadia Publishing at:
Telephone 843-853-2070
Fax 843-853-0044
E-mail sales@arcadiapublishing.com
For customer service and orders:
Toll-Free 1-888-313-2665

Visit us on the Internet at www.arcadiapublishing.com

To all who cherish the heritage of skiing.

All royalties from the sale of this book will go to

the New England Ski Museum.

CONTENTS

ACKNOWLEDGMENTS

Many of the images in this book come from the photograph archives of the New England Ski Museum in Franconia, New Hampshire. We should like to thank the museum staff, Linda Bradshaw, Kay Kerr, Liz Lambregtse, and director Jeff Leich for help on various occasions. Paul Bousquet has been an enthusiastic supporter from the beginning, and we acknowledge his help and the loan of his photographs. To Harry Craven, Susan Denault, Neil Doherty, Tom Eastman, Al Fletcher Jr., Bill Gilbert, John Hitchcock, Dave Kenney, Mort Lund, Channing and Jane Murdoch, Mary Rose O'Connell, and Jay Pagluica, we offer many thanks.

We are also grateful to the archivists of the historical societies of Adams, Blandford, Littleton, and North Adams; the Concord Free Public Library; the Concord Museum; the Randy and Ida Trabold Collection at the Massachusetts College of Liberal Arts; and the Berkshire Eagle.

INTRODUCTION

From immigrant skiing through the development of skiing as a sport to the fast-paced Alpine *boom-schuss* period, Massachusetts has provided venues for entrepreneurs to make the state one of New England's most popular ski choices. With the large urban populations of Boston and its suburbs and with Pittsfield, Worcester, and Springfield nearby, there was a significant clientele to be enticed into enjoying winter on skis.

In the early years from the 1870s until the 1920s, usually under the guidance of Norwegian immigrants, skis were useful means of getting about in winter. But gliding on skis started to appeal to the wealthier sectors of society. Williams College, for example, first encountered skiing in 1914 and reacted strongly enough to field a relay team three years later. Skiing thus changed into a sport while retaining much of its healthy, outdoors attractiveness and closeness to nature.

The first major boom in skiing coincided with the increasing transportation opportunities for reaching favored skiing hills. On arrival, the skier would find mechanical contraptions to lift him or her to the top of the hill. Lifts—mostly rope tows of varying efficiency—turned skiing into one of the great vogues in the 1930s. In the same years, the sport also benefited from a second wave of immigrants, who brought "Alpine" skiing with them. A low crouch and a lift and swing swept the upright telemark turn from the hills. With the "magic of the CCC"—the depression-spawned Civilian Conservation Corps—Massachusetts's wooded hills were singled out for ski-trail development and the Berkshires soon became the state's premier region for skiing.

Now the sport appealed to a new type of person. Once the tradition of Scandinavian immigrants, then of university men and graduates, in the 1930s, skiing would often be the sport of the professional classes, people far more interested in social aspects than in physical betterment. They had to be taught how to ski, where to ski, what to wear, even what to say. Ski instructors, news reporters, and the hotel and clothing industries were wooing these skiers with fancy advertising. Much of this was put on show at the annual exhibition in the Boston Garden.

In the 1920s, cars belonged to the well-to-do; in the 1930s, the regular schedule of the Boston and Maine Railroad's snow train—first bound for the hills of New Hampshire—meant a day or even weekend for common city dwellers to enjoy fun in the snow and sun. From 1935 on, the Berkshires, too, were well served by trains from Grand Central Station in New York.

These new initiates to skiing had so much to learn, not merely how to ski—best illustrated in early photographs of the Appalachian Mountain Club's instructor, Otto Schniebs—but also what to wear. The skier was bombarded with promotions from four specialty shops—Hambro, Osborne, Ski Sport, and James Byrne, all represented here—but also from large department stores such as Wright and Ditson, Filenes, and others who employed skiing experts (an Alpine accent was all but required) to give advice and make sales.

Ski centers also advertised. The Weldon Inn in Greenfield became synonymous with good skiing because it employed Norwegian immigrant and 1929 National Jumping Champion Strand Mikkelsen as resident instructor. Mikkelsen used terms like *telemark turn* (from a district in Norway) and *Langrenn* (a cross-country run), but soon his vocabulary was superseded by the Austrian lingo of the Alpine skiers. In 1937, one beginner's book, for example, listed stemmed

ski, *Langlauf, Dauerlauf, Gelaendesprung, Quersprung, Klister, Bahnfrei,* and *Vorlage* as "necessary for the understanding of a ski lesson."

Part of the success—one could argue a major part—of the Alpine Arlberg form of skiing was due to the popularity of films made by the German Arnold Fanck, which starred the world's skimeister Hannnes Schneider and his St. Anton ski school from the Arlberg region of Austria. Schneider starred in 12 films, perhaps the three most influential being *Wunder des Schneeschuhs* (Wonders of Skiing), *Der weisse Rausch* (White Ecstasy), and *Die Fuchsjagd im Engadin* (shortened to The Fox Chase) in which Schneider and Leni Riefenstahl are pursued by the St. Anton instructors, enchanting the spectators with a magic rush over the pristine snow in the winter wonderland of the high mountains. It did not matter that Massachusetts had no Matterhorn, for what was presented was the ideal fantasy of skiing.

More prosaic, but essential to the development of Massachusetts skiing, were the photographers working in the state. The 1930s photographs made by men like Harold Orne, Charles Trask, Randy Trabold, Bart Hendricks, and doyen Winston Pote are represented. The New England Ski Museum holds Christine Reid's photographic archive, and images of her various interests in all facets of skiing are reproduced here, some for the first time.

The ski journalist became, for many, the guide to the increasingly involved ski world such as "Old Man Winter" of the *Boston Evening Transcript*. Famed newsman Lowell Thomas broadcast from a number of Massachusetts ski centers. The audience was the increasing number of skiers joining all types of clubs: wealthy and influential ones such as the AMC and Ski Club Hochgebirge as well as city clubs like Lowell's Black and Blue Trail Smashers, Woburn's Innitou Ski Runners, the White Mountain Ski Runners, the 5,000-member Springfield Ski Club, the Broken Bones Club, and others. In 1934, Massachusetts was home to 15 of the 55 member clubs in the United States Eastern Amateur Ski Association; by 1941, the number had risen to 45 out of 100 member clubs.

World War II put skiing development on hold. After the war came the growth years; the ski center turned into the ski area as lifts became more sophisticated and snow making essential. J-bars, T-bars, and chairlifts proliferated. Equipment became specialized, clothes warmer, and skiers more experienced. They searched for longer and steeper runs in the states to the north, out in Colorado, and even in Europe, as the first packaged ski holiday flew out of Boston in 1954. The photographs depict this growth in the state.

This seemingly endless upward move came to a sudden halt with the oil embargo of 1973. With the decline of Alpine skiing—requiring energy at all levels—Massachusetts took up what was first called the cross-country craze but which developed into a specialty of its own, with cross-country centers pulling in an increasing number of devotees.

In the 21st century, the ski area has been expanded to include real estate development with year-round facilities. Skiing is only one of the attractions on the leisure menu offered to slope-side condominium owners. Snowboarders, at first on a collision course with skiers, became an integral part of an area now offering "snow sports." During the summer, ski areas double as hiking, mountain biking, fishing, music, and movie venues. Butternut Basin, Jiminy Peak, Mount Wachusett, and Catamount are symbols of this development.

We have been particularly fortunate in having at our disposal the photograph archives of the New England Ski Museum and of Paul Bousquet. These images show that there were indeed—and still are—"Millions of Flakes of Fun" to be found in Massachusetts.

1

MASSACHUSETTS:

NATURE'S GIFT TO SKIERS

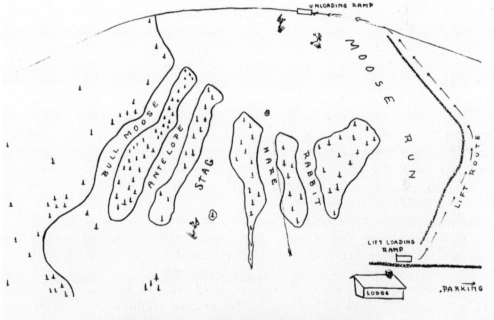

THIS IS MOOSE HILL!

About 10 miles from Worcester, Moose Hill offered family skiing for novices and intermediates and even a 60-degree slope for experts. Tractors pulling trailers carried people to the top. By 1938, it was important to advertise the easy parking, available lessons, and safety provided by the ski patrol. The Moose Run was a big draw. At 300 feet wide, it was a novice's delight, and the huge majority of skiers in the 1930s were beginners. (Courtesy New England Ski Museum.)

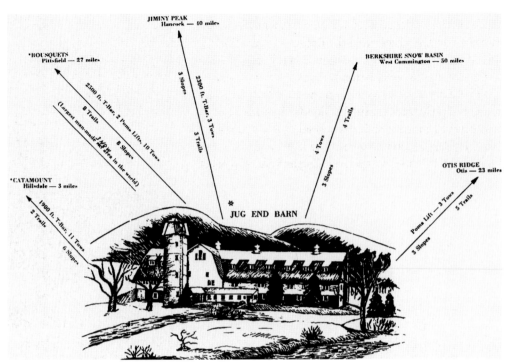

The curiously named Jug End Barn of Great Barrington (from the German *Jugend*, meaning "youth"), presenting itself as the center of the state's dependable snow regions, combined the modern ski hostelry of the 1960s with the historic and natural farm. The 1,000-foot novice slope was assured by snow making, and the area also included steeper slopes and trails. (Courtesy New England Ski Museum.)

Skiers experienced Europe in America at Mount Tom. The Austrian eagle and "Ski" in German script promoted the ski school. Handsome and bronzed instructors wearing patterned Alpine sweaters swirled down the slope in their flawless, reverse-shoulder technique, so popular in the mid-1960s. They promised an exciting time in the school, as well as vast improvement in one's own skiing. (Courtesy New England Ski Museum.)

Halfway between Greenfield and North Adams, Chickley Alp claimed easy access from the Boston–Albany Boston and Maine Railroad route and from Greenfield on the New York, New Haven, and Hartford's line to White River. North Adams was also located on the New York Central's route. Strand Mikkelsen, the Weldon Inn's resident instructor in Greenfield, doubled as ski school director to Chickley Alp, a center that could handle 6,000 skiers per hour in the 1940s. (Courtesy New England Ski Museum.)

Season 1949
(10th Year)

Chickley Alp

7 Tows

Charlemont, Mass.
On the Mohawk Trail
Route 2

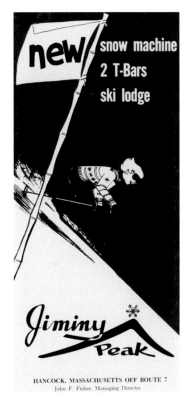

new snow machine
2 T-Bars
ski lodge

Jiminy Peak

HANCOCK, MASSACHUSETTS OFF ROUTE 7
John F. Fisher, Managing Director

In spite of new and improved snow-making machines, five tows including a new T-bar to the top, trail improvements, and a stunning new base lodge of glass, aluminum, and native wood, in 1960 Jiminy Peak only operated Saturday to Monday and during Christmas and other holidays—with an admission price of just $4. (Courtesy New England Ski Museum.)

MASSACHUSETTS

NATURE'S GIFT
TO SKIERS

Magnificent terrain. Ideal conditions for the expert skier or the novice. Quick and comfortable transportation. These are the advantages that are making Massachusetts a leading skiing center in America.

Myriads of mirror-smooth lakes for skating, ice boating and curling. Snow trails for hiking and riding. Thrilling, swift slopes for toboggans, and smooth expanses for snowshoes.

And, after a day of keen sport, the restful comfort and the fine food for which Massachusetts' hotels, inns and guest houses are famous. All within reach of a modest purse.

**THE MASSACHUSETTS DEVELOPMENT
AND INDUSTRIAL COMMISSION**
State House, Boston, Mass.

The Massachusetts Development and Industrial Commission promoted the state as a leading winter sports center in the country in the 1938 *American Ski Annual*. There was much competition from the northern neighbors of Vermont and New Hampshire. Although various centers—the expression "ski area" was not in use until after World War II—advertised their own delights, each of the New England states tried to lure the clientele from the major urban areas. Massachusetts's eastern region of the Berkshires attracted the New York and Albany crowd. Many Bostonians traveled north to New Hampshire. The appeal of the state was its excellent snow conditions, choice of accommodation, good transportation network both south–north and west–east, and its attractions of other winter sports. (Courtesy New England Ski Museum.)

Bousquet Ski Area saw itself as a family ski area in the 1975–1976 season. The brochure at right was placed in state information booths on the major highways and on ski and sport shop racks. Like all advertising, it was directed toward a certain clientele, one happy to be at Bousquet's, where $100 would give a family a weekend pass, a lesson, and rental equipment. The outdoorsman/instructor below, although sporting a vaguely Austrian eagle logo on his sweater, is promoting the Canadian-run ski school, which claims to have "the only standardization of ski teaching in the world." As a sign of the times, Bousquet's states that it is "the only ski area in America adjoining an airport." Not many came by air, since road connections to the major cities of New York, Hartford, Springfield, Boston, and Albany were all good. (Courtesy New England Ski Museum.)

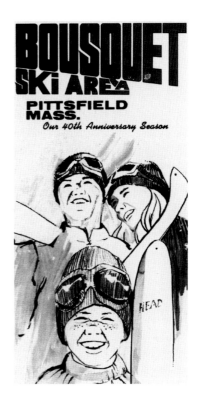

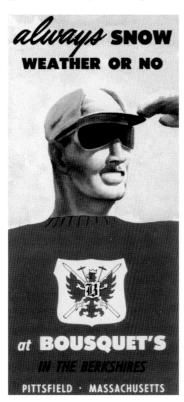

The effort to attract the urban skier persuaded entrepreneurs to make skiing possible in the Boston region. Page Hill was just off Route 128 near Peabody. Lift tickets were available for short time periods in the morning, afternoon, and evening. Equipment could be rented for a half-day, full day, or weekend. Skating, tobogganing, and socializing were all part of Page Hill's offerings. (Courtesy New England Ski Museum.)

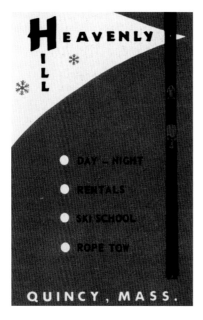

Even nearer to Boston, only 12 minutes away from the city center, was Heavenly Hill on the Furnace Brook Golf Course in Quincy. Designed entirely as a beginners' slope, and with a name that bore no threat at all, it offered day and evening skiing along with rental equipment. Dixie and Bill (no foreign accents here) taught skiers the fundamentals and how to ride the rope tow. (Courtesy New England Ski Museum.)

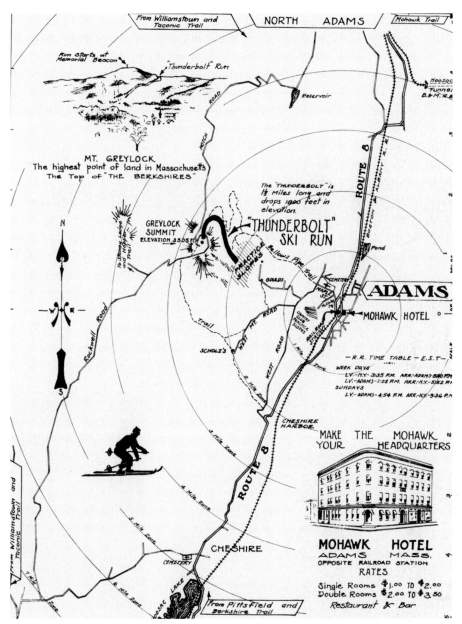

The Mohawk Hotel of Adams, no longer in existence, capitalized on its proximity to Mount Greylock and carefully listed its Class A Thunderbolt ski run as over a mile long and with a drop of about 1,800 feet. It also had a novice practice area at the foot of the trail. From the top, if the Thunderbolt proved too difficult, the Bellows Fire Trail took the skier the roundabout way into town, and there were more novice slopes just out of Adams at the country club. Thanks to being on the north–south corridor served by Route 8, skiers could come north from Pittsfield. More importantly, Adams was on the railroad line from New York, and with the special Sunday evening train, skiers could be off the slopes and back home in Manhattan in just over four and a half hours. (Courtesy New England Ski Museum.)

S K I

IN

PITTSFIELD

"Heart of the Berkshires"
**Where the Snow
Trains Come**

Claiming, as a number of ski centers did, that Pittsfield was "the heart of the Berkshires" accessible by snow train, this brochure from the 1930s is an appeal to the fast trail skier. Trail skiing was New England's way to ski, since the wide-open slopes of the European Alps or the Western Rockies were impossible for most people to reach during the Depression. (Courtesy New England Ski Museum.)

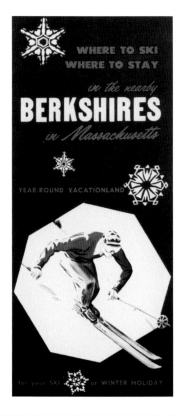

In the 1960s, the brochure for the Berkshires listed a number of venues for skiing. Lodges and, most important, various chambers of commerce were touting the region as a year-round vacation destination. But in winter, one could be the smooth and fast downhiller who came to enjoy what the Berkshire ski areas had to offer. (Courtesy New England Ski Museum.)

Capitalizing on Bill Koch's surprise silver medal win in the 30-kilometer race at the 1976 Olympics in Innsbruck, Austria, the Great Brook Ski Touring Center offered the serenity of cross-country skiing. The surge in the sport's popularity was due in part to America's sudden fitness fad. (Courtesy New England Ski Museum.)

GREAT BROOK FARM
SKI TOURING CENTER

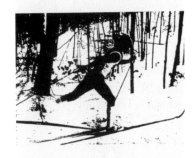

**Great Brook Farm State Forest
Carlisle, Massachusetts**

*Our aim ...
Is to make today
One of the best days
Of your life*

South Road Cummington, MA 01026
Phone (413) 634-2111

CUMMINGTON FARM

SKI TOURING CENTER

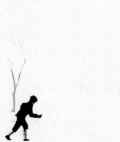

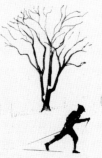

Touring centers opened up in the 1970s during the oil crisis years and stressed the cross-country delights of starry nights along old stone-walled tracks. In Weston, evening tours were offered over conservation land. Cummington Farm was portrayed as part of the natural world as opposed to the mechanical lift of the downhill skier. (Courtesy New England Ski Museum.)

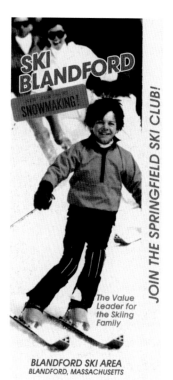

JOIN THE SPRINGFIELD SKI CLUB!

The Value Leader for the Skiing Family

BLANDFORD SKI AREA
BLANDFORD, MASSACHUSETTS

With a few lean snow years and increasing competition from nearby expanding areas, the Springfield Ski Club found itself in economic difficulty at its own Blandford area. Snow-making became essential. Directors sold Snow Making Bonds to the membership, and in 1983–1984, the club was again enjoying skiing and continues to sponsor an active program today. (Courtesy Blandford Historical Society.)

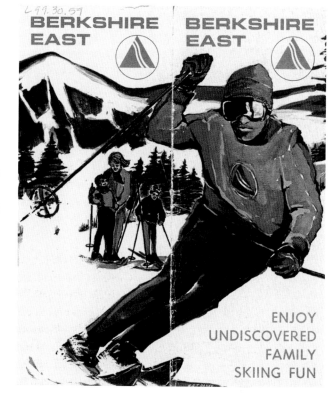

In the 1960s, the family was still the focus of Berkshire East's brochure, but now Mom has two well-outfitted children in hand while Dad has become an expert in the latest Austrian style. The Austrian technique had enjoyed much success in the 1930s, and after the war it remained influential until an American ski technique was engineered by the newly founded Professional Ski Instructors of America in 1961. (Courtesy New England Ski Museum.)

Ski clubs boomed in the 1930s. The United States Eastern Amateur Ski Association was founded in 1922 with seven clubs, none of which were in Massachusetts. About 12 years later, there were 55 clubs in the association. Mount Greylock Ski Club was one of 15 from the state. There were very few competent skiers in the early 1930s, so the wide slopes portrayed here were good practice for club novices and children. (Courtesy Cal Conniff.)

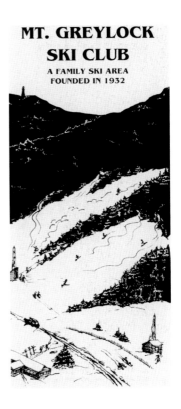

MT. GREYLOCK SKI CLUB
A FAMILY SKI AREA
FOUNDED IN 1932

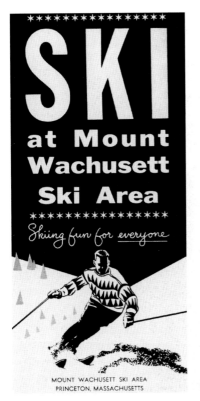

MOUNT WACHUSETT SKI AREA
PRINCETON, MASSACHUSETTS

Mount Wachusett near Princeton got its skiing start with Civilian Conservation Corps (CCC) trail cutting in 1934. By 1962, it had two T-bars, one of them the longest in New England at an exhausting 3,800 feet. Presently, the ski area is within the Wachusett Mountain State Reservation and provides skiing and snowboarding on 100 acres. Out of ski season, one can enjoy the Chilifest, Musicfest, Applefest, and an autumn winefest. (Courtesy New England Ski Museum.)

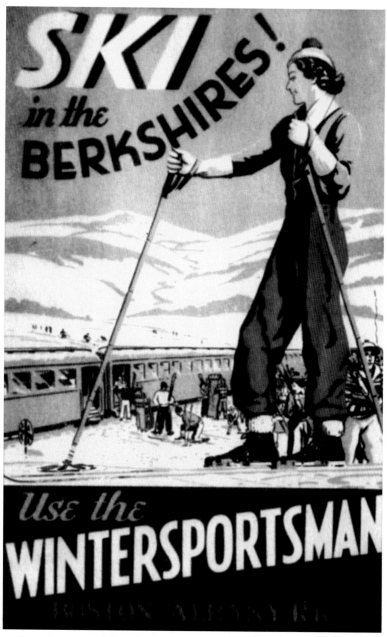

Taking its cue from the successful Boston and Maine Railroad, which had started regular ski train runs on weekends out of Boston in January 1931, the Boston and Albany promoted its Berkshire ski train, the *Sportsman*. Skiers liked to be thought of as sporting, traveling on the *Skimeister* and even on the *Suntan Special* in the spring. In the days before the whole infrastructure of ski development had taken place, the train simply stopped near the ski hills and acted as the lodge—a place where one could leave their gear, return for a picnic, chat, rest, and find old friends and make new ones. The snow train had a real social attraction for urban singles. The Berkshires provided a wonderful region for skiers—novice, intermediate, and expert alike. (Courtesy New England Ski Museum.)

SKIING'S EARLY DELIGHTS

This is the day when each heart
opens wide
And the old carols gaily ring
a Merry Christmastide.

The long Norwegian skis with well-rounded tips take a couple speeding down a slope past a Massachusetts farm. Although few in numbers, Norwegian immigrants initiated early skiing and formed clubs in the local community, such as in Pittsfield about 1910. That year only 51 Norwegians lived in Berkshire County, of 5,432 Norwegians in Massachusetts. (Courtesy E. John B. Allen.)

Prior to the 1920s, skiing was a daring sport for women. This artist did not bother with reality, although the use of a single pole was usual. The poet also made claims for this woman that were in the realm of fantasy. When Dr. Andreas wrote a long column on Norway's sport in a Boston paper in 1912, he included women, suggesting that it would improve their health. (Courtesy E. John B. Allen.)

The wonderful thrill of your skis, my dear,
Your wonderful skill and ease, my dear,
You start—you're off—now here!—now there!
Then shoot like an arrow into the air.

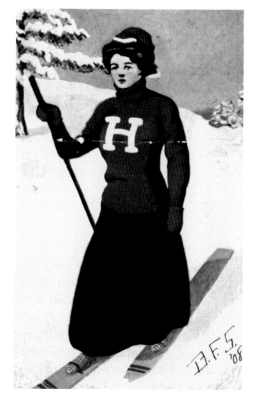

This athletic girl of 1908 sports a Harvard sweater. By this time, the idea of skiing as a sport was beginning to germinate. Before, it had been a utilitarian pursuit, but now the wealthier in society were turning it into something social and fun-filled. The well-to-do male university students were often the first to try skiing for sport; very few women followed until the 1920s. (Courtesy E. John B. Allen.)

SKIING'S EARLY DELIGHTS

The notion of a winter weekend, let alone a winter vacation, did not take hold until the 1920s. A few inns, such as the Northfield in the snowy northwestern part of the state, remained open with winterized rooms, but as the postcard shows, skiing was a sideline compared to tobogganing and snowshoeing. (Courtesy E. John B. Allen.)

Ryan and Buker of Cambridge evidently found the sexiness of a *skieuse* enough to obtain custom for their wares: classroom and laboratory furniture, window shades, crayons, and writing supplies. As evidenced here, by 1931, skiing is being used to sell something not remotely connected with the sport; even the avant-garde did not dress like this on a winter excursion. (Courtesy E. John B. Allen.)

RYAN & BUKER

MEMOBOOK

FEBRUARY

1931

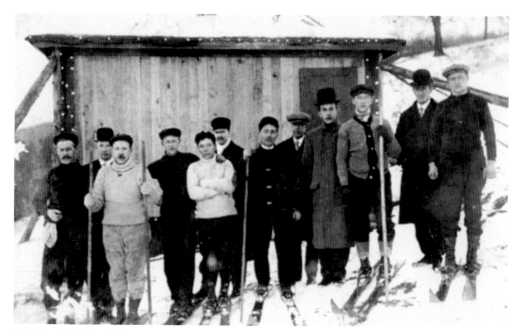

The Pittsfield Ski Club is pictured here in 1910. Dominated by Norwegian immigrants—including the Olsens: Antoine (third from left), Charles (third from right), and Andres (far right)—the club took to outings on skis. One of the skiers has two poles, two have one pole each, and Andres Olsen carries no poles. This non-standardization of equipment and ideas about how to ski was typical in the early days. (Courtesy Berkshire Eagle.)

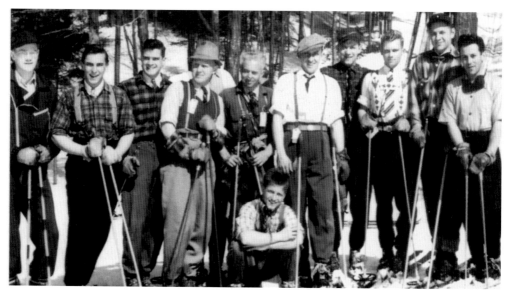

Members of the 1938 Adams Ski Club make no attempt at a club uniform or even a badge. These fellows are mill town locals out to enjoy themselves on a sunny spring afternoon. There were many clubs that enjoyed the local trails, often helping to build them and the resting houses that often followed. (Courtesy Berkshire Eagle.)

SKIING'S EARLY DELIGHTS

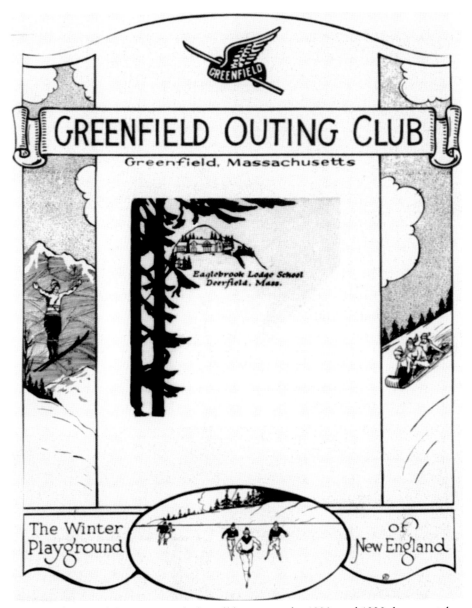

GREENFIELD OUTING CLUB

Greenfield, Massachusetts

Eaglebrook Lodge School
Deerfield, Mass.

The Winter Playground of New England

Greenfield's Outing Club was particularly well known in the 1920s and 1930s because it boasted Strand Mikkelsen, a Norwegian immigrant and national champion in 1929, as resident instructor for the Weldon Inn. It is no mistake that the letterhead portrays the jumper; there were two jumps of 20 and 50 meters in the local park. Greenfield was also known for its cross-country possibilities, however. When the downhill Arlberg technique became popular in the 1930s, Greenfield's Sheldgren Trail was just over 2,000 feet long with a descent of 375 feet, a wonderful novice training run. The insert is Eaglebrook's notepaper. This private school in Deerfield was a leader in interscholastic ski racing in the late 1920s and 1930s. The school had its own ski field with a 100-foot vertical served by a rope tow until a longer area was developed, which remained open until the Easton Ski Area started nearby. (Courtesy New England Ski Museum.)

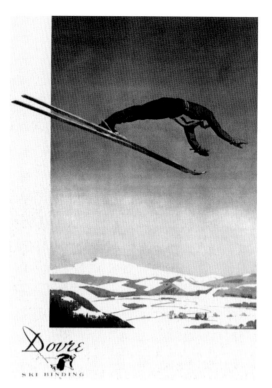

Dovre
SKI BINDING

This magnificent image depicts a perfect jump showing the 1940s and 1950s High Flyers elongated forward lean, chest and arms parallel with the skis. Quite correctly, the heels are raised. The bindings are highlighted because this is a poster for Norwegian immigrant Leif Nashe's Dovre bindings, manufactured in Concord. (Courtesy New England Ski Museum.)

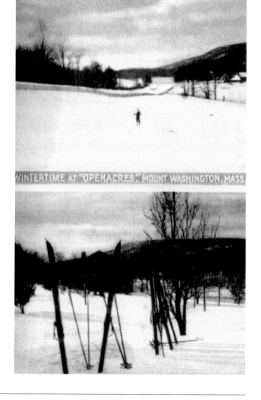

The flat landscape of Massachusetts's Mount Washington was exactly what people enjoyed in the 1920s as they skied across the countryside. Note the heel-free bindings. Before the development of ski areas, inns became the centers for skiing. Openacres, near the corners of Massachusetts, Connecticut, and New York, was able to capitalize on folks coming from Boston and Springfield, Hartford and New York. (Courtesy E. John B. Allen.)

SKIING'S EARLY DELIGHTS

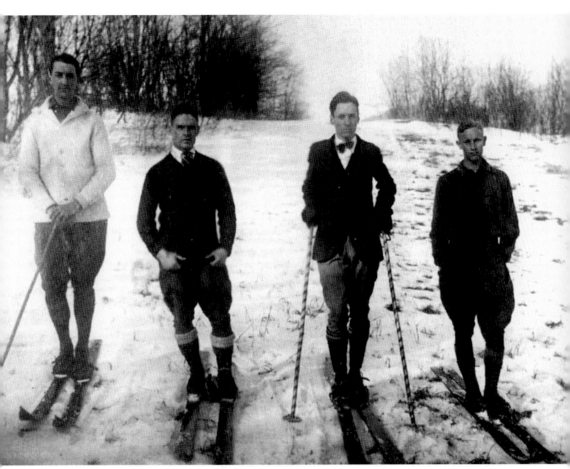

J. S. Apperson, who had skied with the Dartmouth Outing Club, wrote to Ford Sayre, assistant to the Williams College president, in 1914 suggesting that student officers of the two colleges' outing clubs meet informally "in a political exchange of ideas and plans." Under this impetus, Williams took up skiing and in 1917 was strong enough to field a relay team (again, note the pole usage) that included Roland Palmedo, seen here wearing a bow tie. Palmedo went on to become a major figure in American skiing of the 1930s as entrepreneur, race organizer, sponsor of the American women's teams for the Fédération Internationale de Ski, FIS World Championships, and Olympic Games in 1935 and 1936. In 1938, he edited the handsome ski book *Skiing: The International Sport.* He died in 1961. (Courtesy Berkshire Eagle.)

Skiing is a favorite sport at . . .

EAGLEBROOK SCHOOL

DEERFIELD **MASSACHUSETTS**

C. THURSTON CHASE, JR., Headmaster

Pioneered the sport 28 years ago. Our students receive expert ski instruction. Winter Carnival highlights the Winter Term. High academic standards. Grades 4 through 9.

— CATALOGUE UPON REQUEST —

This advertisement in the *American Ski Annual* of 1951, promoting one of the state's many private schools, is obviously aimed at the skiing parent. In the postwar years, there were enough skiing families that might well consider Eaglebrook for their son's education. In Deerfield, the school would be conveniently located near Springfield and the Connecticut river towns, as well as Boston. (Courtesy New England Ski Museum.)

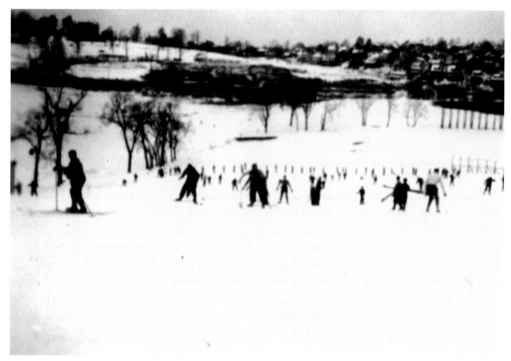

It is difficult to realize that some downhill skiing took place on what might be considered almost cross-country flats today. This is where a rope tow would be placed, a lone Austrian immigrant would command a sizable following, and all would have wonderful thrills and spills at the Commonwealth Country Club in Newton in 1940. (Courtesy New England Ski Museum.)

SKIING'S EARLY DELIGHTS

OHN W. McCRILLIS WALLACE RAND

MEMBERS OF THE PARTY

ough Abbe	. . .	Brookline
Olive E. Anson	. ,	Worcester
M. Anson	. .	"
mrs. Amory		*Dedham*
Roy E. Bates	. .	Gardiner, Me.
Margaret Blake	. .	Weston
Natalie Browning	.	Cambridge
ond Bunker	. .	Wellesley Hills
Carpenter .	. ,	Boston
Caroline Chapman	. .	Bridgeport, Conn.
Alice Chapman	. .	Worcester
l E. Chase	. .	Lynn
'eter P. Chase	. .	Providence, R. I.
Peter P. Chase .	. .	"
Barbara Clarke	. .	"
r Comey .	. .	Cambridge
Olive L. Cox	. .	"
Gertrude Elkins	. .	Boston
Caroline W. Fisher	.	Newton
Katharine S. Fowler	.	New York
Elizabeth G. Garland	.	Newton
Nellie D. Horner	. .	Lowell
Marjorie Hurd .	. .	Cambridge

Miss Gwendoline Keene	.	. Brookline
Charles C. Kimball	. .	. Andover
Miss Elizabeth Knowlton	.	. Boston
Miss Edith B. Lamprey	·	. Jamaica Plain
Philip H. Lewis	. .	. Lynn
Bessie J. Laing		
Colin MacR. Makepeace		. Providence, R.
Mrs. Louise C. Maranoff	.	. Brookline
John W. McCrillis	. .	. Newport, N. H.
Mrs. John W. McCrillis	. .	"
Leo J. Moore	. .	. Milton
Helen morton		
Avis E. Newhall	. .	. Lynn
Wallace Rand Newton Highlan
Miss Pauline Randall	.	. Wollaston
Miss Elizabeth W. Reed	.	"
Miss Martha Robinson	.	"
Otto Schniebs .	· .	. Waltham
Miss Helen S. Shepherd	.	. Newton
Gerald J. Spicer	. .	. Dorchester
Robert P. Stephenson	.	. New York
Miss Florence Stiles .		. Cambridge
Warren Taylor		"
F. H. Underhill	.	. Chestnut Hill
R. L. M. Underhill	.	. Cambridge
Bartlett Walton	. .	. Wakefield
Miss Helen S. Wasgatt	.	. Waban
Miss Helen Wheeler .	.	. Bridgeport, Cor
Dr. F. W. White	. .	. Boston
William H. Willcomb	.	. Lynn

The Appalachian Mountain Club (AMC) of Boston, a society for science-oriented gentlemen who embraced the environment for the interest in nature, its spiritual qualities, and its recreational challenges, had the occasional "skee-man" on winter trips as early as 1895. By 1929, the club was sponsoring major ski excursions for their male and female members under their own club leaders. On this occasion, they brought their own immigrant instructor who had been fortuitously found in a Waltham watch factory, Otto Schniebs. The participant list reads like a partial who's who of late-1920s Massachusetts—and New England—skiing: Greenough Abbe, writer of skiing articles and trailblazer in Vermont; Park Carpenter, snow train organizer; Arthur Comey, ski mountaineer and the man who first suggested the Inferno Race; Marjorie Hurd and Gwendolyn Keen, two socialite-skiers; Jack McCrillis, maker of the first downhill ski film; and Schniebs himself, who went on to coach at Dartmouth. (Courtesy New England Ski Museum.)

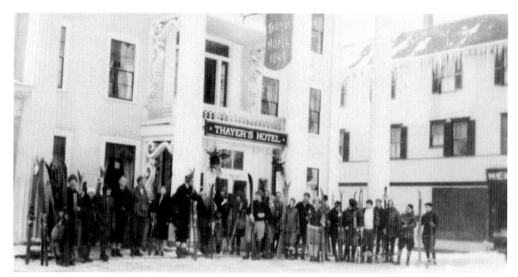

This group photograph of the 1929 AMC trip was taken outside Thayer's Hotel in Littleton, New Hampshire, which is still in existence. The AMC took skiers as far north as Quebec. Others like the Dartmouth Outing Club of Boston had a nucleus of skiers, too, before specific ski clubs such as the Ski Club Hochgebirge emerged. (Courtesy New England Ski Museum.)

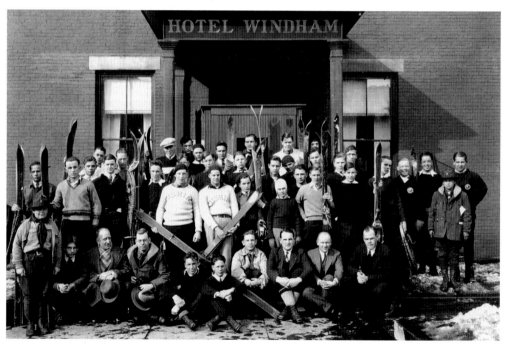

The Interscholastic Prep School meet of 1930 was held in Brattleboro, Vermont. Representing Massachusetts were Cushing, Clark, Deerfield, Eaglebrook, Mount Hermon, Middlesex, and St. Marks. Other schools came from Vermont, New Hampshire, Connecticut, and New York. Seated on the ground third from the right is Eaglebrook master Roger Langley, future secretary and president of the National Ski Association of America. (Courtesy New England Ski Museum.)

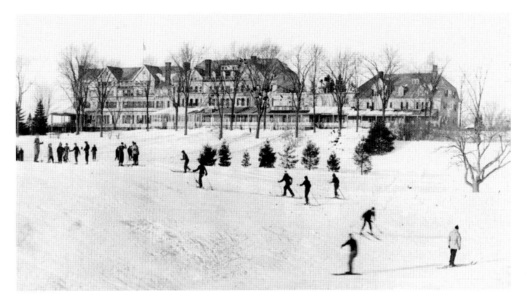

In the 1930s, inns like the Northfield could still count on a clientele that did not need much more than novice slopes for their skiing. These two postcards depict the patrician quality of the 19th-century inn, with undulating snowfields literally outside the verandas. There seemed to be an endless line of beginning skiers with enough disposable income to enjoy sporting in the snow from an old, established inn that promised a typical New England welcome along with tea, billiards, and other quiet attractions. In the postwar years, the inn was run by the Northfield School for Girls and included a 400-foot rope tow. The Northfield School closed in 1970 to become partners with Mount Hermon, a boys' school. The inn was torn down. (Courtesy E. John B. Allen.)

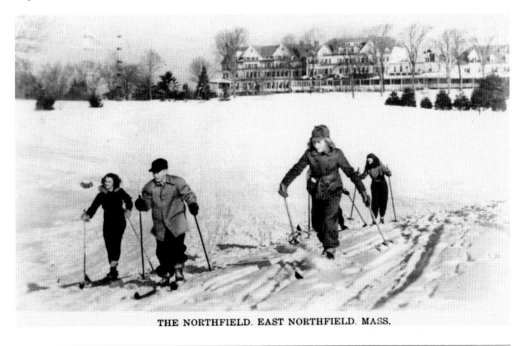

THE NORTHFIELD. EAST NORTHFIELD. MASS.

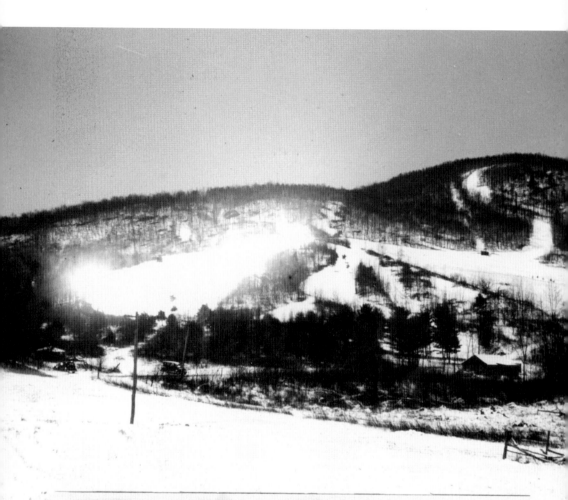

WORLD'S FIRST ARTIFICIAL LIGHTING SYSTEM AT A SKI AREA 12.24.1936

Ready for Christmas in 1936, Bousquet's offered the world's first night skiing under incandescent lights, thanks to General Electric, which saw it as an experiment in sports lighting. Previously, car lights had been left on so enthusiasts could try their turns, but under the new lights, Bousquet's began a trend that is continued today. This photograph was taken by Bart Hendricks, one of Massachusetts's most influential skiers. (Courtesy Paul Bousquet.)

SKIING'S EARLY DELIGHTS

3

TRAVELING TO
SKI COUNTRY

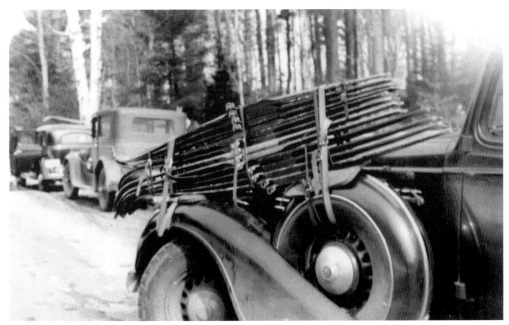

Boston provided the great reserve of skiers flocking to terrain in northern and western Massachusetts. Roads were kept plowed, and from 1931 on, snow trains offered a comparatively cheap and easy access to ski country. Individuals made their own car rigs for carrying skis—even if the driver could not see much when making left-hand turns. (Courtesy New England Ski Museum.)

The Snow Train

is now open with a wide collection of authentic, gay, colorful ski toggery

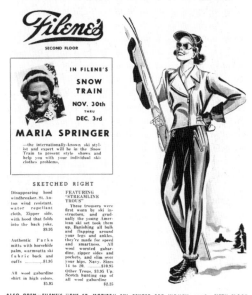

The biggest innovation in ski travel came with Boston's snow train. Filene's, a large Boston emporium, must have gauged the train popular enough to advertise its ski clothes in a mock-up in the store. An expert was on hand in the pre-Christmas season for retail sales and advice. (Courtesy E. John B. Allen.)

The economically secure sectors of society were the major promoters of skiing, taking their pleasures out in snow country in winter and in the sand dunes of Cape Cod, particularly at Centerville, in summer. Sand skiing was practiced in New Mexico and abroad in Japan, and one woman even tried to cross the Sahara on skis. (Courtesy New England Ski Museum.)

The Boston and Maine Railroad had promoted with minimal success the "winter vacation habit" as early as 1907. In the 1920s, with the growth of local carnivals to the north of Boston, special trains allowed spectators to watch the shows, which sometimes included "the breathtaking skill of ski jumping . . . from dizzy heights." (Courtesy New England Ski Museum.)

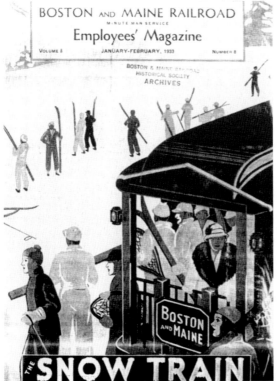

Around six years later, the Boston and Maine's magazine had a special Snow Train number carrying well-dressed, well-equipped, eager skiers ready to join the group already enjoying one of the regular snow train destinations. In fact, 1933 was a poor snow year, as the railroad handled only 7,703 passengers, down from over 10,000 the winter before. (Courtesy New England Ski Museum.)

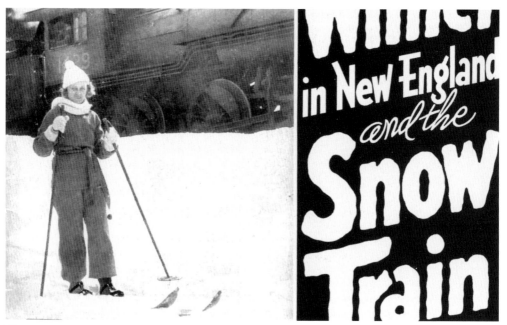

The Boston and Maine ran a regular Snow Train from January 1931 up to World War II. At Boston's North Station, skiers would congregate for the trip north. This 1936 brochure, at 46 pages long, included time-tables and advertisements for lodging and meals. A new winter business was in the making during the difficult Depression years. (Courtesy New England Ski Museum.)

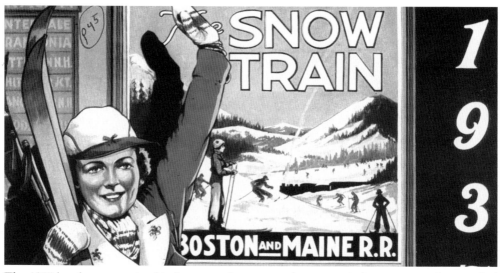

The 1937 brochure contained information for novices: last season's destinations, where to find meteorologist E. B. Rideout's reports from radio station WEEI (the Friday Boston and Worcester newspapers), and where equipment could be rented (Armstrong's Winter Sports Car). The long list of hotels included the Northfield for $3.75 a night, the Weldon for $2, the Williams Inn for $5, and Sunnyacres at Winchendon for $2. Weekly rates varied from $12 to $21. (Courtesy New England Ski Museum.)

Snow Train Season

To have the most enjoyment you must have proper equipment. We outfit many of the most prominent skiers. We can help you.

CHARLES N. PROCTOR (former Olympic skier)
Manager Ski Department

Canvas Creepers (patented)—$1.50 a pair

Snowshoes, hockey sticks and other winter sports furnishings

ASA C. OSBORN CO.

175 Federal Street, Boston LIB erty 7070

In the winter of 1936, the Boston and Maine Railroad carried 24,240 passengers to ski country, enough for Osborne's ski shop to advertise the Snow Train season. The image of the jumper was still strong enough to attract patronage even though none of the snow train passengers would attempt such a leap. For a long time, jumping was considered the supreme accomplishment of the skier. (Courtesy New England Ski Museum.)

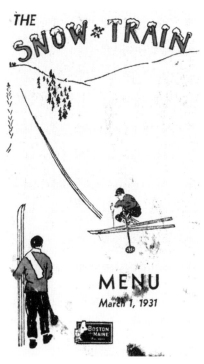

THE SNOW TRAIN

MENU
March 1, 1931

The Snow Train's popularity was partly due to its social ambience. The 1937 brochure advertised low-priced breakfasts (25¢), luncheons (75¢), and dinners ($1) served continuously by courteous waiters. This Snow Train menu offered chicken creole soup, sweet pickles, roast beef, potatoes, beans, strawberry shortcake, cream, bread, butter, tea, or coffee—all for $1. Non-alcoholic drinks and cigarettes and cigars were available in the club car. (Courtesy New England Ski Museum.)

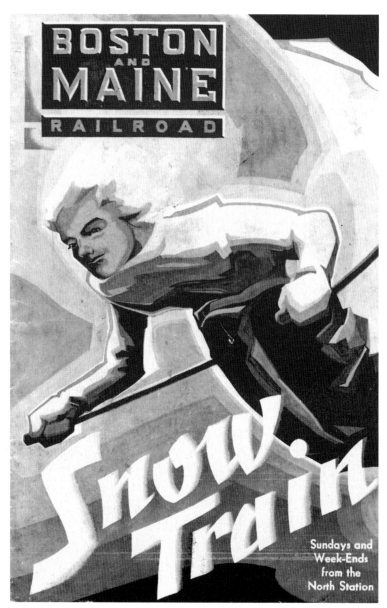

The selection of the Boston and Maine brochures in this book comes from the New England Ski Museum's archives. Each one provides a social picture of what the snow train meant to people. For the 1939 season, the railroad no longer had to answer questions such as "What is this Snow Train?" or "How can I find fun in skiing or other winter sports?" This season trains were scheduled to Charlemont for $5.15 round-trip, East Northfield for $4.90, Greenfield for $4.30, and North Adams for $5.75. The Northfield Inn had raised its price to $4, whereas the Weldon remained at $2 a day. Among the many advertisers were the Armstrong Company, James W. Brine, Asa Osborne, and the Harvard Coop. With plenty of photographs featuring "a typical Snow Train Girl," harmonica playing, ski school, and trips in the snow, it was obvious that the snow train was a great place to enjoy a day or weekend of fun. (Courtesy New England Ski Museum.)

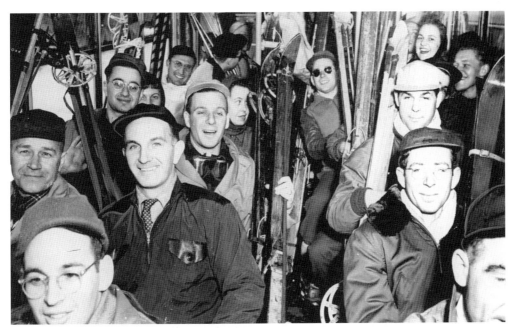

With the success of the Boston and Maine's snow train, other railroads followed. On the initiative of Clare Bousquet, the first snow train from New York City arrived at Bousquet's on February 10, 1935. Four hundred forty-seven skiers detrained at Pittsfield to waiting buses for the two-mile trip to the slopes. In the 1936 season, 3,658 came into Pittsfield from Grand Central Station. (Courtesy Paul Bousquet.)

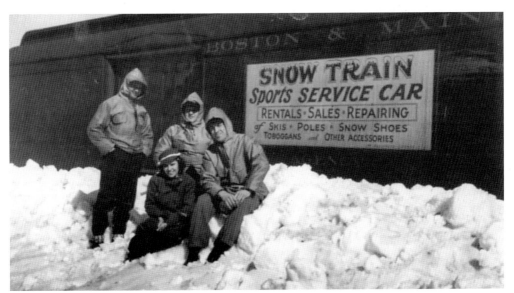

Armstrong's Snow Train Service Car was parked at Platform 3 in Boston's North Station and was open daily from 10:00 a.m. to 7:00 p.m. Equipment and ski togs—as clothing was usually called—could be bought or rented there. On Sundays, the car was attached to the snow train for the trips up north. (Courtesy New England Ski Museum.)

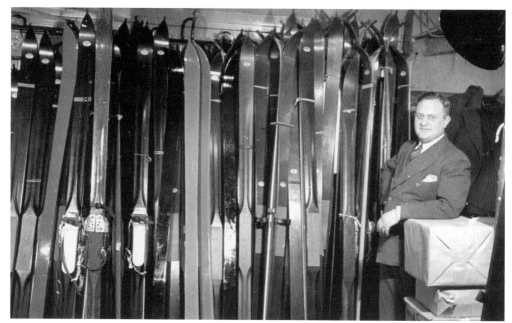

Sam Auerbach, the genial general manager of Armstrong's Snow Train Service Car, poses with a selection of available skis. Many do not have bindings. These could be fitted in the workshop, even while traveling to the snow train destination. Bamboo poles are stacked in the corner. Steel varieties were available by the 1940s. (Courtesy New England Ski Museum.)

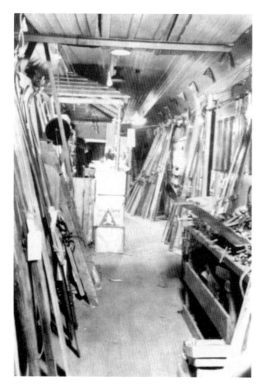

This is the only known photograph depicting the inside of the Armstrong workshop. The store was at one end, and the workshop occupied the other end of the car. A good bench was necessary for fitting bindings and also for waxing skis. One wonders how the stacks of skis kept their position as the train rattled on to its destination. (Courtesy New England Ski Museum.)

TRAVELING TO SKI COUNTRY

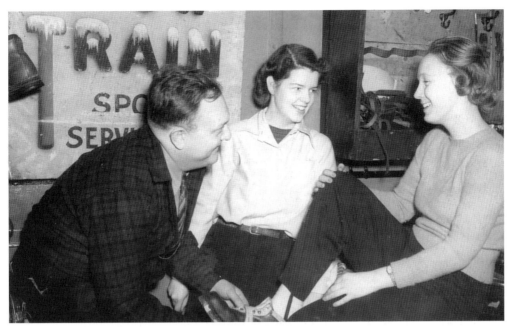

Sam Auerbach is obviously enjoying his job fitting rental boots to two "snow bunnies" in Armstrong's Service Car. By 1940, one could walk in off the Boston streets and be totally outfitted and equipped upon arrival at the snow train destination. Rental skis and bindings (properly adjusted) cost $1.25, poles 50¢, parkas 75¢, pants $1, mittens 25¢ and 35¢, socks 35¢, and goggles 25¢. (Courtesy New England Ski Museum.)

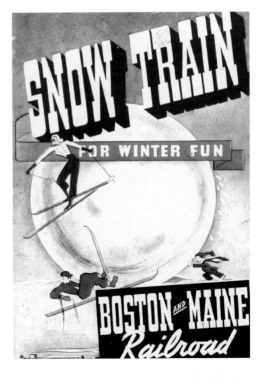

The year 1940 saw the Boston and Maine with the same fares for Charlemont, East Northfield via Greenfield, and North Adams as in the prewar years, but only the Northfield Inn remained in the list of hotels. Advertising was down, and the booklet ran to 35 pages. In North Station, a large board listed conditions at snow train stops: Greenfield 18 degrees, fair weather, and five inches of "breakable crust." (Courtesy E. John B. Allen.)

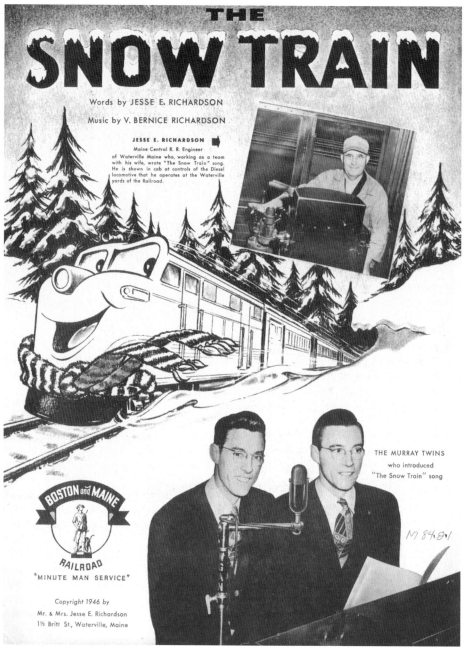

THE SNOW TRAIN

Words by JESSE E. RICHARDSON

Music by V. BERNICE RICHARDSON

JESSE E. RICHARDSON
Maine Central R. R. Engineer of Waterville Maine who, working as a team with his wife, wrote "The Snow Train" song. He is shown in cab at controls of the Diesel locomotive that he operates at the Waterville yards of the Railroad.

THE MURRAY TWINS
who introduced
"The Snow Train" song

BOSTON and MAINE
RAILROAD
"MINUTE MAN SERVICE"

Copyright 1946 by
Mr. & Mrs. Jesse E. Richardson
1½ Britt St., Waterville, Maine

In 1946, railroad engineer Jesse Richardson wrote "The Snow Train" song: "High up in the mount-ains, Let's take a day to be joy-ful / Winter sports we'll find. Out where the skies are blue. / Let's put on our snow togs. It will be fun on the Snow Train / And leave the world behind riding a-long with you." Singing was one of the social entertainments of the ride, often accompanied by harmonica playing. If a car was reserved for a club, factory, or business outing, songfests on the way home provided the continuing camaraderie that had been so evident on the slopes. (Courtesy New England Ski Museum.)

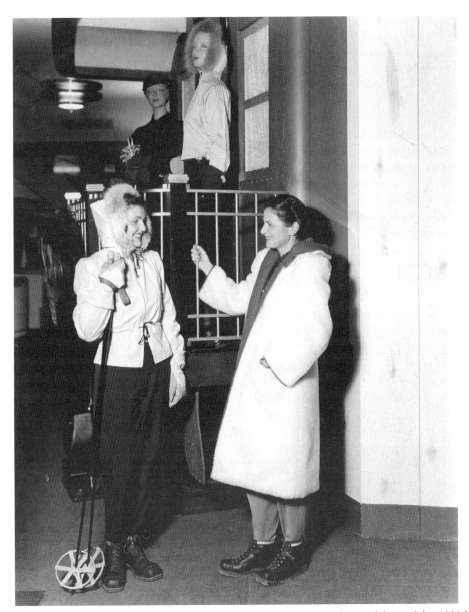

Filene's of Boston used a mock-up snow train to give authenticity to the modeling of the 1939 line of ski ware. On the left, Austrian instructor Maria Springer wears the latest hooded fur parka. Note the shoulder-high poles with huge baskets. Her partner is Bostonian Marjorie Moore Carroll, in après-ski mode in the fur overcoat. Both models don the square-toe leather boots popular into the 1940s and 1950s. Ski shops and large department stores stocking equipment often employed well-known ski personalities—always called experts—to attract the novice crowd, dispense advice on equipment, and just to talk so knowledgeably about skiing. Springer had the added advantage of being able to chat about the European Alps in her German accent. What Alpine Europeans had to say about skiing was more or less taken as gospel until well after World War II. (Courtesy New England Ski Museum.)

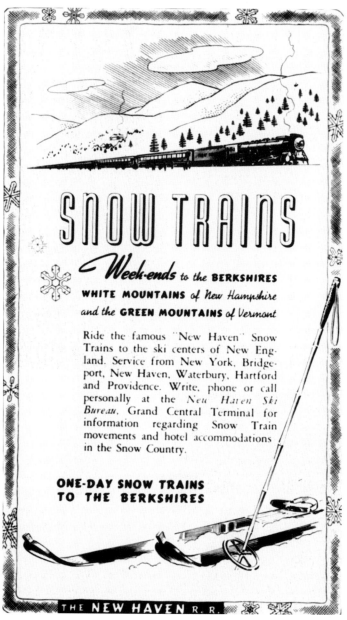

SNOW TRAINS

Week-ends to the BERKSHIRES
WHITE MOUNTAINS of New Hampshire
and the GREEN MOUNTAINS of Vermont

Ride the famous "New Haven" Snow Trains to the ski centers of New England. Service from New York, Bridgeport, New Haven, Waterbury, Hartford and Providence. Write, phone or call personally at the *New Haven Ski Bureau*, Grand Central Terminal for information regarding Snow Train movements and hotel accommodations in the Snow Country.

ONE-DAY SNOW TRAINS TO THE BERKSHIRES

THE **NEW HAVEN** R. R.

The New Haven Railroad began to run its own services to ski country, advertised here in the 1936 *American Ski Annual*. New Yorkers boarded at Grand Central Station, and the train made stops on the route north at the Connecticut towns of Bridgeport, New Haven, Waterbury, and Hartford. Other trains left from Providence, Rhode Island. Both daily return trips to the Berkshires as well as weekends were advertised, including trips to the Green and White Mountains farther north in Vermont and New Hampshire. When service started in 1935, the skiers created such a curious sight that the line to get on the platform was roped off. On-lookers could get a good view of the strangely garbed folk carrying the long boards. This experience was, wrote one journalist, "New York's newest spectator sport." (Courtesy New England Ski Museum.)

"Hitler would let you down" but one advertiser in the Boston and Maine's 1942 brochure (23 pages in this war edition) certainly would not. Specials left from Worcester and another from Rockport, stopping at Gloucester, Manchester, Beverly, Salem, Swampscott, and Lynn. The Northfield and Weldon Hotels remained open with higher winter prices. Round-trip fares had increased very slightly from 1939. (Courtesy New England Ski Museum.)

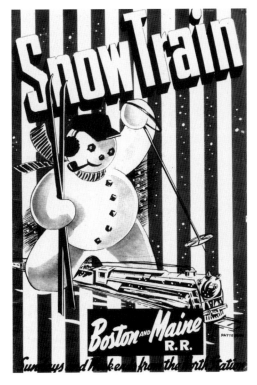

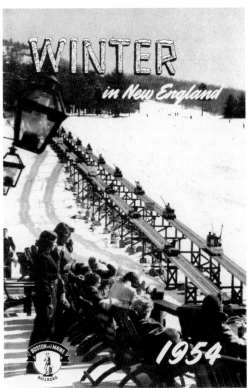

After World War II, skiing experienced tremendous growth, with more venues, vastly improved lift capacity, and better equipment. The sport was becoming integrated into tourism as a business. Trips, carnival events, and Snow Train Queen contests, all were advertised in this 1954 Boston and Maine brochure. But times were changing; the automobile would soon become the vehicle of choice for the city dweller. Bus trips by city ski clubs also offered competition to the snow train. (Courtesy New England Ski Museum.)

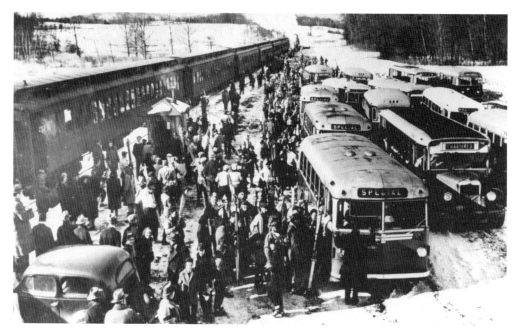

From 1935 until 1946, the New York Central ran trains to a siding near Pittsfield. In 1940, buses were waiting to take the skiers on to Bousquet's. At $3 a round-trip ticket, about 10,000 skiers enjoyed the Berkshires via the snow trains. Bousquet's remained open during the war years, offering free skiing to servicemen and servicewomen on leave. (Courtesy Paul Bousquet.)

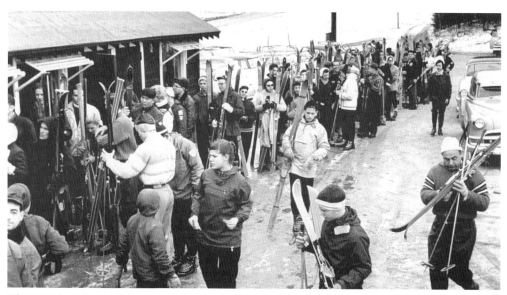

The crowd is off the ski train and lining up for tickets at Bousquet's in the 1950s. Skiing, which had once been a healthy outdoorsman's sport, has become a city dweller's sport and amusement. In fact, it was so popular that the line waiting for the day's ski admission became like the line one waited in to buy a movie ticket in town. Urban problems were being brought to the countryside, but few minded. (Courtesy Paul Bousquet.)

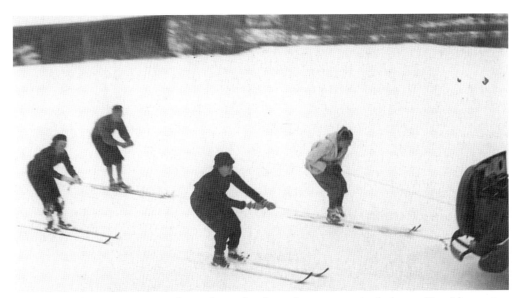

Originating from Norwegian military dispatch riding, skijoring required a horse. Here Norwegian immigrant O. Lie Nielsen of Boston demonstrates skijoring behind a car with, from left to right, Mary Hall, Christine Reid, and Florence Davol, all of Brookline, before the Massachusetts Committee to Further Outdoor Recreation. No date is given but the photograph was likely taken in the late 1930s. (Courtesy New England Ski Museum.)

Social standing was a consideration for membership when the White Mountain Ski Runners of Boston was founded in 1933. Paul Bird, one of the prominent members, prepares for a spring ski trip. The long bamboo poles of shoulder height and the Norwegian style cap mark him as one of the better skiers. (Courtesy New England Ski Museum.)

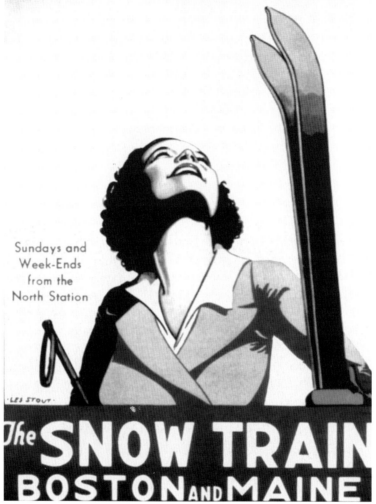

you'll have a glorious "Sun-day"

Sundays and Week-Ends from the North Station

·LES STOUT·

The SNOW TRAIN
BOSTON AND MAINE

This spectacular Boston and Maine poster by Les Stout says it all. By 1939, the single girl has taken the train, had a few frolics in the snow, perhaps even learned a stem-turn from one of those bronzed Austrian instructors, enjoyed socializing with friends, acquired a marvelous spring suntan and, indeed, experienced a glorious Sunday. And what tales she will tell back at the office on Monday morning! Between 1931 and 1935, the Boston and Maine had carried about 59,000 to ski country. For the years 1936 to 1940, the number had risen to around 175,000. In the late 1930s, the railroad was marketing suntan specials. No wonder some of the old crowd talked about the hills turning into Coney Island. Even Florida became worried that New England would draw off its sun-worshipping clientele. (Courtesy New England Ski Museum.)

4

Uphill Made Easy

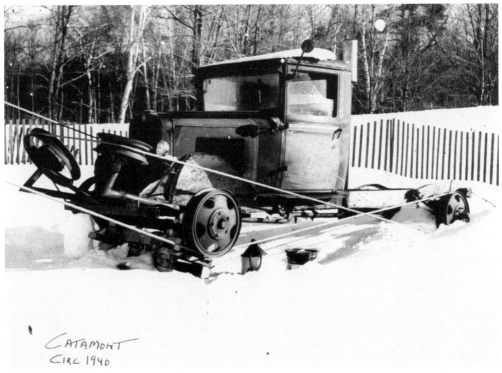

CATAMONT
CIRC 1940

The first rope tows in the country, from 1934 on, were usually put up by ingenious tinkerers using old cars and trucks for power and rigging a rope up to a bull wheel, which was tied to a tree at the top of the slope. Someone had to sit in the driver's seat, foot to the pedal, to move the rope at speed. Occasionally, he would floor it. (Courtesy Cal Conniff.)

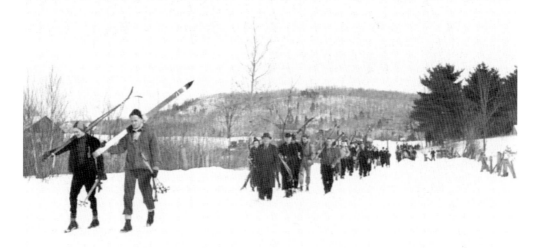

The snow train crowd moves out of Pittsfield for the two-and-a-half-mile bus trek on Tamarack Road. In 1935, Pittsfield had set aside $40,000 for upgrading the road into Bousquet's; the town realized what an economic boom skiing would bring. Clare Bousquet provided parking and a new shelter, along with rope tows. (Courtesy Paul Bousquet.)

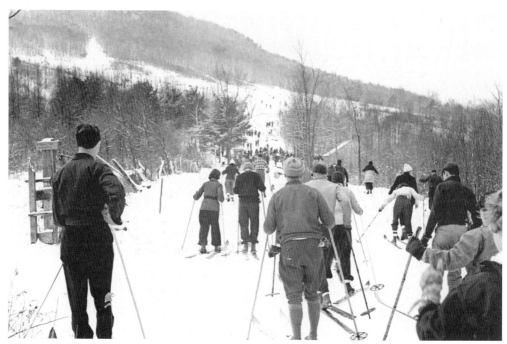

Nearer to the skiing grounds, visitors can see the sweeping run, cleared by Mount Greylock Ski Club members. Two rope tows of 1,400 and 1,000 feet await this crowd. Bousquet's famous run, 40 to 75 feet wide, dropped 570 feet in about half a mile. In 1935, it was the most popular in the Berkshires. (Courtesy Paul Bousquet.)

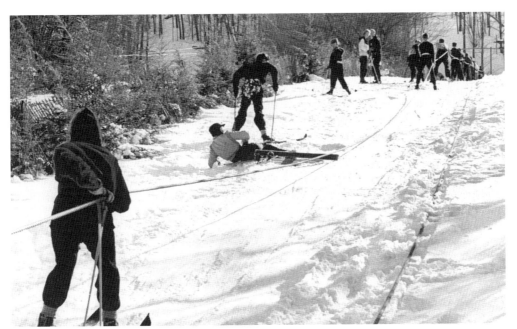

Early rope tows were fairly inefficient. They dragged in the snow, which made them heavy, and when a person fell off, others behind often piled up. The ropes tended to twist as they moved along, which also made them slippery. The tracks became icy. In all, it was quite an exhausting experience, yet the rope tow became ubiquitous at Massachusetts centers. (Courtesy Paul Bousquet.)

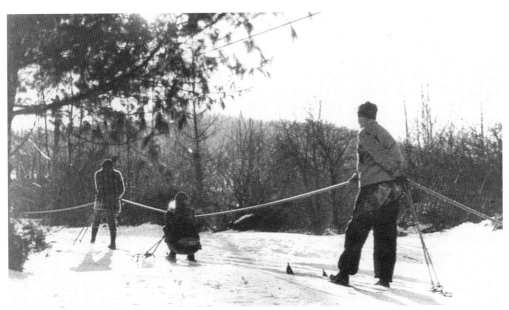

Grown-ups often put children in between them on the rope to keep its heavy weight off the ground. On the other hand, some people tried to get an easy ride up by squatting and letting others bear the weight. The man on the right is in the correct position: ski pole loops around the wrist of the hand behind his back, so that he does not slip backwards. (Courtesy Paul Bousquet.)

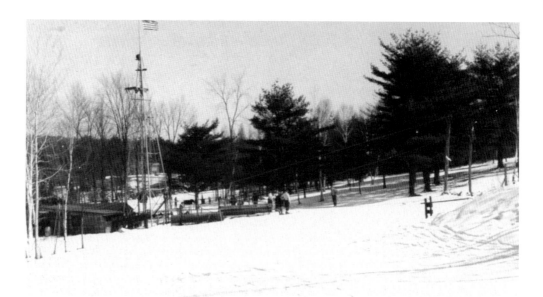

With this improved Bousquet's tow, the rope is held up by wheels mounted on wooden stanchions, thus keeping it off the snow. The oil rig–like construction houses a heavy counterweight to ensure that the rope remains held up. Riding the rope, after all, had to be less sweat than walking up. (Courtesy Paul Bousquet.)

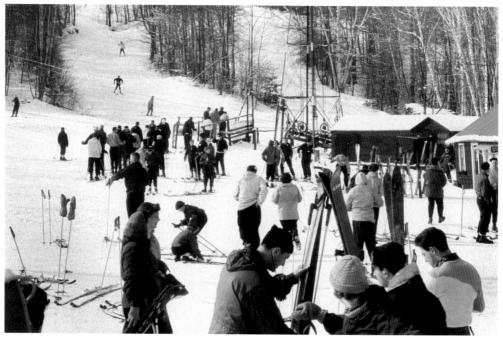

This general scene at the bottom of Bousquet's is typical: quite a few skiers stand around, forming a line for the tow in the back. The line makes its way toward a narrow, fenced entrance. There is no attendant; the skier simply gets in position and grabs the rope with increasing firmness as he moves along the flat, then up the hill. (Courtesy Paul Bousquet.)

UPHILL MADE EASY

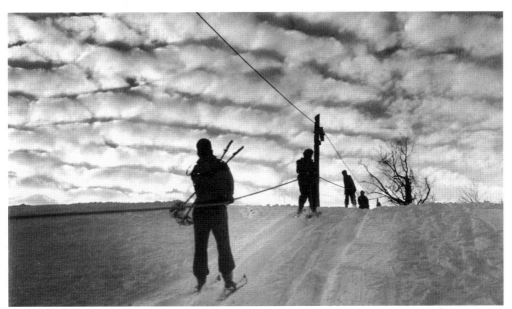

Under a mackerel sky—harbinger of snow to come—Springfield skiers ride the rope tow at Blandford in the 1940s. Each skier relinquishes the rope as it goes over a wheel attached to a pole, then instantly grabs it again on the other side. It may sound difficult to do, but it was in fact quite easy. (Courtesy Blandford Historical Society.)

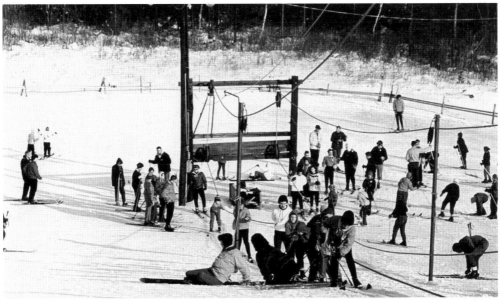

With the popularity of skiing growing after World War II, ski area owners increased lift capacity. The rope tow was cheap and easy to build, and maintenance was usually restricted to engine fatigue. During the 1961–1962 season, the wooden frame works for two ropes and metal poles hold the wheels for the high returning rope. There has been a fall and already five people are bunched together. (Courtesy Paul Bousquet.)

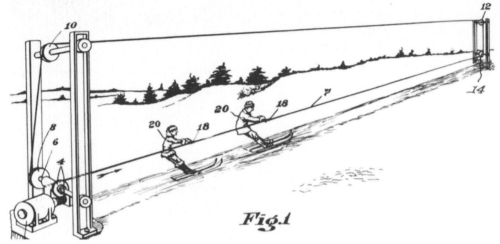

May 4, 1937. T. C. COOKE 2,079,491

SKI TOW APPARATUS

Filed Dec. 23, 1936

Fig.1

In 1937, Ted Cooke of Swampscott was granted a patent for a motor-driven endless rope moving along at hip height and being returned overhead. Skiers held a special gripper whose tines twisted the rope enough to hold them on as they mounted. Put up for Boston's White Mountain Ski Runners in New Hampshire, it was moved for the 1940–1941 season to the Commonwealth Country Club in Newton. (Courtesy New England Ski Museum.)

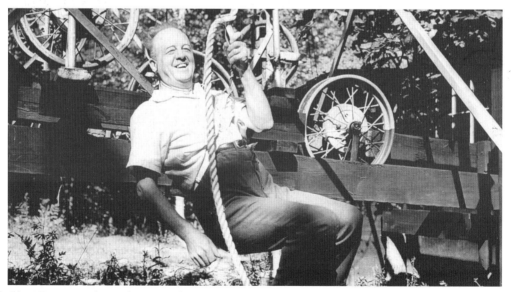

Clare Bousquet shows the strength and simplicity of his rope tow gripper in this marketing shot. He reportedly made more money from the sale of his gripper than he did from his ski center. In 1941, special grippers "personal for women" were manufactured by the Underwood Machinery Company of South Boston. (Courtesy Paul Bousquet.)

"Rest While You Ride": Clare Bousquet knew that, for novices especially, the ride up on a rope tow could be the most exhausting part of the skiing day. The pull of Bousquet's tow was from a belt that the skier wore like any other piece of clothing. The actual gripper, which held the rope firmly, was only used when it was his or her turn. (Courtesy New England Ski Museum.)

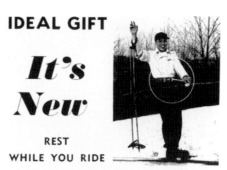

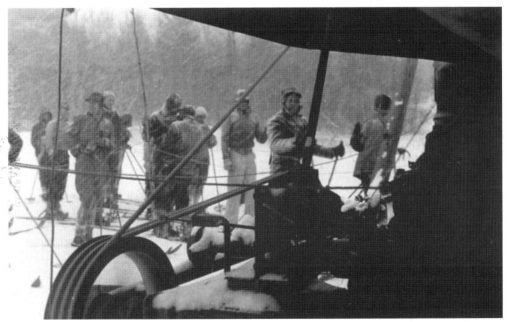

When Ted Cooke received his rope tow patent, the drawing showed an utterly simple electric motor. In reality, the gasoline engine with its complicated series of wheels and belts often broke down. Skiers were willing to accept this because once working well, the rope tow allowed for much more skiing than in the old days of hiking up. (Courtesy New England Ski Museum.)

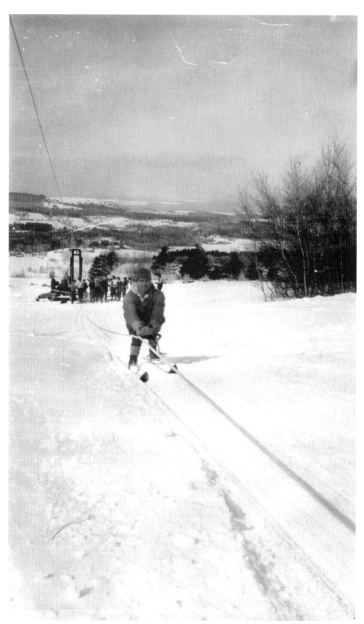

Hollis Phillips of Swampscott rides Ted Cooke's tow in 1935. With only one person, the rope dragged on the snow, thus becoming very heavy and continually soaked and slippery. Even so, Ted Cooke was able to think that his "equipment is perfected for all practical purposes, and we can look for only minor improvements in the future." The accounts do not bear this out; for the 1936–1937 season, Cooke had expenses of $225 and income of $151. His best month was January 1938, which brought in $312 but expended $305. Patently, this was not a money maker. By 1936, there was also competition from the Hussey Manufacturing Company of Maine. Hollis Phillips went on to win the first Inferno Race, skiing from the top of Mount Washington to the AMC hut at the bottom in just over 14 minutes. (Courtesy New England Ski Museum.)

UPHILL MADE EASY

With the rope tow era underway, rope manufacturers quickly realized a new market. Plymouth Cordage's ropes were free from the surface treatments that could soil expensive ski togs and were made to prevent twisting. Splicing could be done at the factory, by Plymouth Cordage's man in the field, or by the buyer himself, who often had a local expert at the area. (Courtesy New England Ski Museum.)

Sheep Hill, Williamstown, Mass

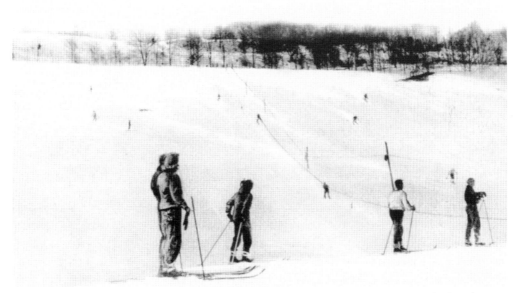

Sheep Hill had two advantages: it was near the winterized Williams Inn and also close to Williams College. An admirable slope for the novice skier, now with a rope tow, it gave students and snow train lovers plenty of scope for practice. Many a Williams College student trekked out to Sheep Hill to watch the carnival races and jumping. (Courtesy E. John B. Allen.)

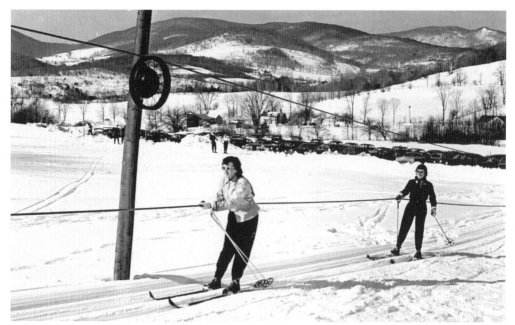

These two women on Jiminy Peak's rope tow around 1950 would not recognize the area today, with six chairlifts headed by the top-to-bottom six-passenger Berkshire Express. The Welcome Center, Children's Center, cafés, taverns, and real estate buildings are all situated at the center of the lift system. However, advanced as all these attributes are, these women did not have to pay the 2006–2007 price. (Courtesy Cal Conniff.)

Rope tows created the permanent Alpine ski areas. They required a suitable track up the hill and trails to come down where the rope stopped. Only a few tows were portable. The great difficulty was stopping the rope from twisting. Jug End Barn's rope was put up in the early 1940s. (Courtesy E. John B. Allen.)

UPHILL MADE EASY

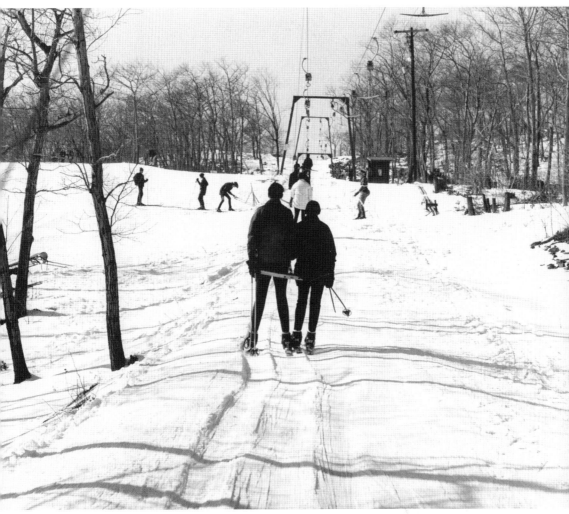

Following the rope tow, new inventions arrived on the scene: first the J-bar, then the T-bar, known in the early days as the "he-and-she-stick," indicating just how social skiing had become. The T-bar replaced the rope tow in the 1950s, and was eventually replaced itself by the chairlift. This 1969 photograph clearly shows the steel construction holding the wire up at Mount Tom. The bars are suspended via a spring-loaded mechanism that allows the skier flexibility to take bumps and adjust to the angle of the slope. An attendant must stand at the loading area, catch the T-bar, and force it down so the skier can lean against it. T-bars were expensive when compared to rope tows, but much cheaper than chairlifts. (Courtesy Cal Conniff.)

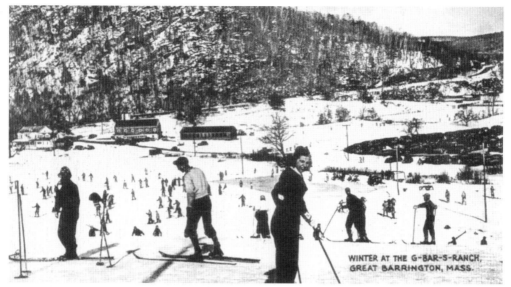

WINTER AT THE G-BAR-S-RANCH,
GREAT BARRINGTON, MASS.

One of the early popular resorts near Great Barrington was the G-Bar-S Ranch, shown here in 1939 (above) and in the 1940s. Run as a dude ranch in the summer, it became a select skiing venue with a rope tow, parking lot, and easy access by rail. It languished after the war but in 1962 and 1963, new ownership turned it into Butternut Basin. These 1930s and 1940s skiers would not recognize the area today. It now includes 22 trails, 10 lifts with the ability to handle 13,172 skiers per hour, a tubing center, cross-country center, ski school, and patrol. The 2006 price of $229 rises to $279 in December for the 2006–2007 season. The Day Lodge, designed by a protégé of I. M. Pei, has been recognized by *Snow Country* as one of the finest in the country, and the area won *Ski* magazine's environmental excellence award. (Above, courtesy E. John B. Allen; below, courtesy Cal Conniff.)

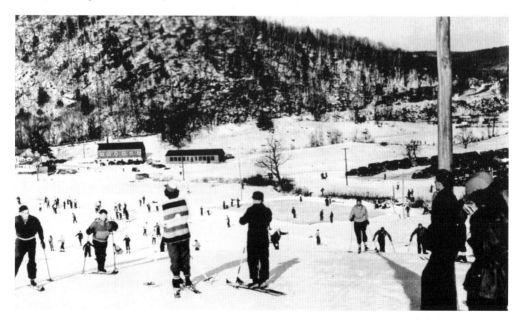

UPHILL MADE EASY

Bousquet's was changing with the times. By the winter of 1960, the new T-bar is telescopic, thus giving the rider a smoother takeoff. Crowd control is instituted in the form of lanes to get to the T-bar, but by the looks of things, the ski area should have employed a car parking attendant. (Courtesy Paul Bousquet.)

T-bars became easier to ride after the war. Wooden stanchions gave way to steel, cables ran smoothly on wheels suspended securely, and the T-bar wire came from a spring roll that let out when the skier mounted, thus giving a gradual takeoff. Nowadays, the valley below this original Jiminy lift is filled with buildings. (Courtesy Cal Conniff.)

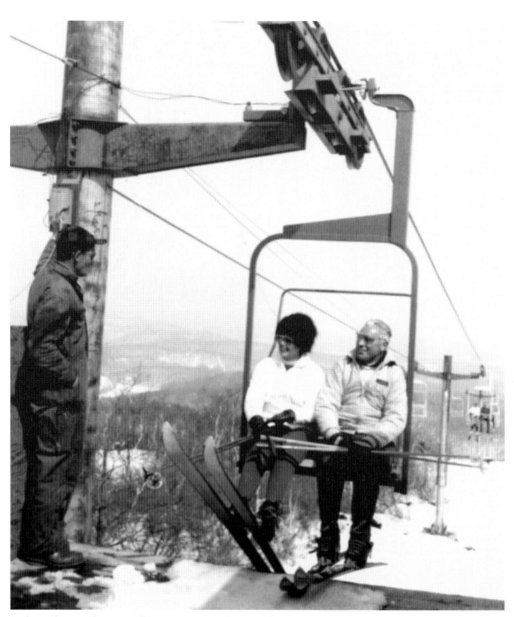

Riding the newly opened 1963 summit chair with Catamount ski school director Toni Matt is Florence "Flukie" Fisher, who with her husband, Jack (likely the man at left), owned the 1,000-foot vertical area. Toni Matt came to the United States in 1939 after a distinguished career as racer and instructor in Hannes Schneider's St. Anton ski school. He is always remembered for his mad downhill descent in the 1939 Inferno Race on Mount Washington, in which he cut the time down to six and a half minutes. Matt also won 10 downhill races in New England, going on to teach at Sun Valley and in Montana before directing the Catamount ski school. This chairlift will be converted to a high-speed quad for the 2006–2007 season. (Courtesy Cal Conniff.)

UPHILL MADE EASY

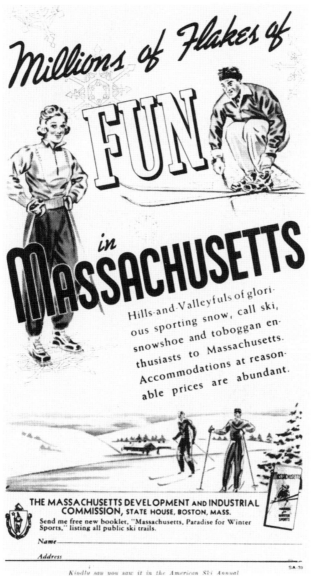

Health, sport, and sociability contributed to Massachusetts's appeal for the ski enthusiast at the end of the 1930s. The experience was now made even better by car and train travel, warmer clothing, available ski schooling, and up-ski conveyances in all parts of the snow-laden state. Just send for the free booklet *Massachusetts: Paradise for Winter Sports*. This advertisement appeared in the 1939 *American Ski Annual*. Also promoting themselves were New York State, another "Paradise for Skiers!"; the Eastern Slope Region of New Hampshire; and Vermont for "New Thrills in Grand Ski Country." Farther afield were the "Perfect Winter Sports Country" of Oregon; the "Winter Sports Capital of the West," Yosemite; "Friendly Quebec"; and "for the best in high alpine ski-ing," the Canadian Rockies. The competition for the skier's dollar was continent wide, and Massachusetts's areas were lucky to have large urban centers nearby. (Courtesy New England Ski Museum.)

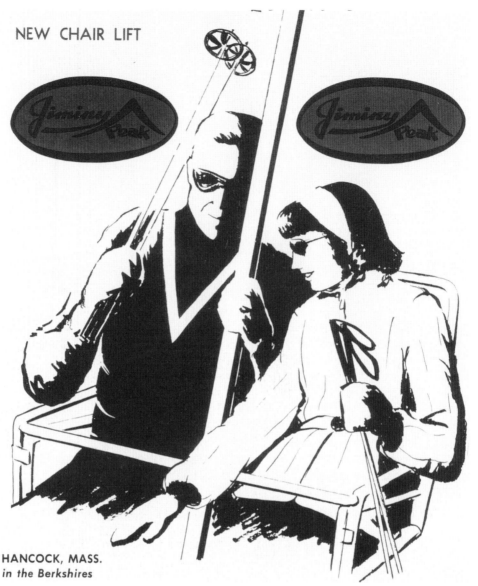

NEW CHAIR LIFT

HANCOCK, MASS.
in the Berkshires

Jiminy Peak had the state's first T-bar in 1948, added ropes, and eventually installed this double chairlift in 1964. Presently the area boasts a high-speed six-person chairlift. In 2006, besides the winter activity, real estate is being developed in the form of condominiums and townhouses, and the summer possibilities appear endless. Mountain Adventure Park, with its new 2,600-foot German-made Mountain Coaster, has become the latest addition. The area includes lift-serviced mountain biking, an Alpine slide, Euro bungee, climbing wall, zipline, miniature golf, shopping, and for relaxation, indoor and outdoor whirlpools. It is all very costly to run. Energy expenses in 2004 ran to $782,766, in 2005 to $948,421, and in 2006 are projected at about $1.5 million. Jiminy management has ordered a vast wind turbine to generate electricity in an attempt to keep costs down and help the environment. It will be set up at 2,000 feet, quite near the 10-million-gallon snowmaking reservoir at the summit. (Courtesy New England Ski Museum.)

THOUSANDS ON SKIS

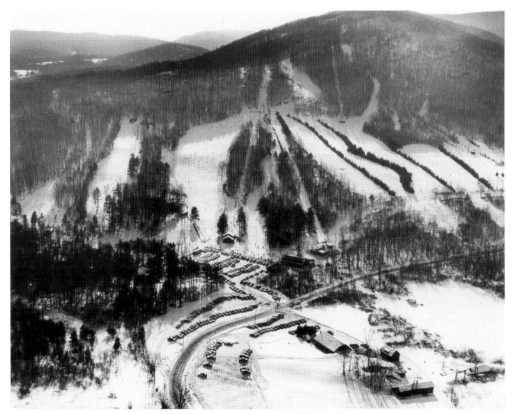

No wonder Bousquet's could be shown off in this aerial view; Clare Bousquet was a pilot. At the time of this 1936 photograph, there were two rope tows and a well-defined trail system, including the first trail cut by the Mount Greylock Ski Club three summers earlier. (Courtesy Paul Bousquet.)

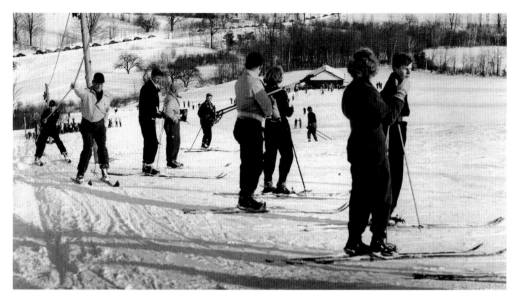

Perfect snow conditions greeted skiers of the Springfield Ski Club at Blandford in 1946. The club was founded in 1936 and, with volunteer help, built its own ski area. It claims to be the oldest club-owned ski area in the country. In this first postwar ski season, the two men on the rope tow are still using their prewar hickories with the knob at the ski tip. (Courtesy Blandford Historical Society.)

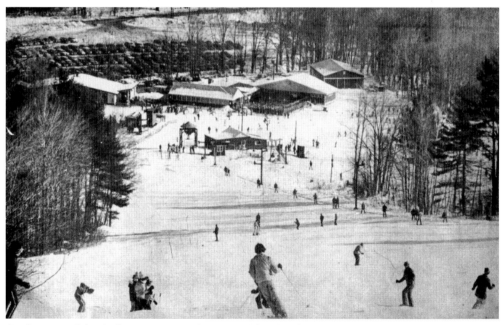

At the time of the 50th anniversary of Springfield's Blandford area in 1986, skiing was as popular as ever, even though much had changed. These differences included the large parking lot, increases in buildings and tows, new T-bar and chairlift, snowmaking, and excellent instruction at a reasonable cost. No wonder; at one time, membership was limited to 5,000. (Courtesy Blandford Historical Society.)

THOUSANDS ON SKIS

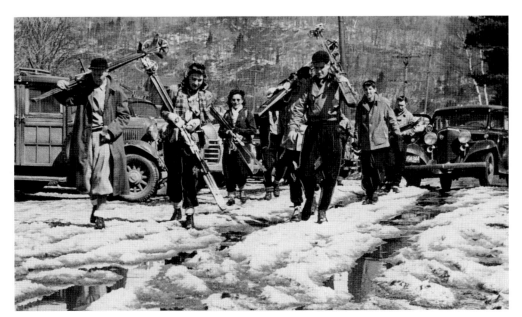

Sloshing through wet snow and mud in ski area parking lots was a common rite of spring. Four-wheel-drive vehicles are not to be seen in this 1947 photograph. Before going on the lifts, waxing the base of the skis was essential to the day's enjoyment. Spring was—and still is—known as mud season in Massachusetts. (Courtesy Paul Bousquet.)

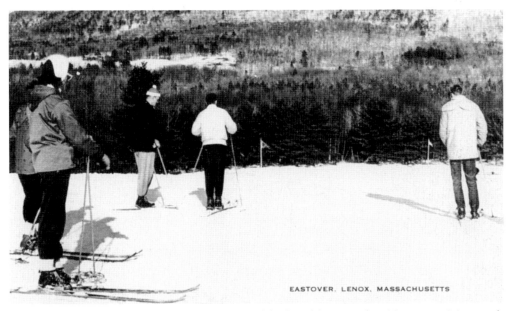

EASTOVER. LENOX. MASSACHUSETTS

Eastover used to be the estate of a New York stockbroker able to employ 65 servants. Many such estates were located in the Lenox area, where the Vanderbilts and Carnegies also had "cottages." After the war, the estate was sold and became a destination resort promising a relaxed vacation in typical Berkshire surroundings with the main attraction being social skiing on a 200-foot vertical served by a chairlift. (Courtesy E. John B. Allen.)

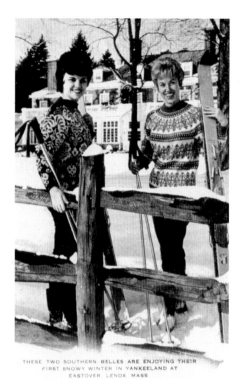

THESE TWO SOUTHERN BELLES ARE ENJOYING THEIR
FIRST SNOWY WINTER IN YANKEELAND AT
EASTOVER, LENOX, MASS.

Southern belles enjoy winter at the Eastover Resort in Lenox in the early 1960s. In 1938, the beginnings of a winter tourist industry could be detected, and skiing became the cause of economic improvement in the region. Skiing may have been the cause of these two visiting the Berkshires, but the Eastover was geared to social activities rather than cold weather sport. (Courtesy E. John B. Allen.)

In 1936, Ayer boasted the largest trestle ski jump in the country. Special trains arrived from Boston for the big jumping competitions, especially when the professionals came to town. Tobogganing, skiing, bobsledding, and snowshoeing were also part of the excitement of the meets. Note the houses and hay wagons with the jump in the background. (Courtesy Cal Conniff.)

THOUSANDS ON SKIS

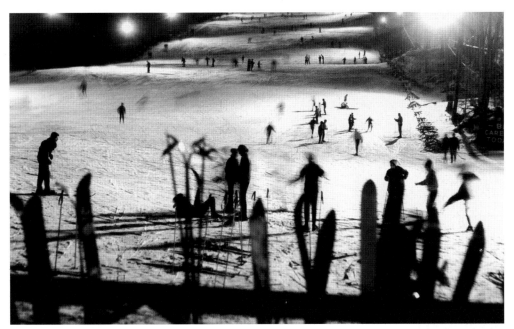

Night skiing became popular at ski areas close to population centers. Mount Tom in Holyoke was one of the largest night skiing venues in the country, at one time operating seven nights a week. On special occasions, the ski school and ski patrol would come down in patterned formation carrying lanterns or lighted torches, which created a spectacular display for the public. (Courtesy Cal Conniff.)

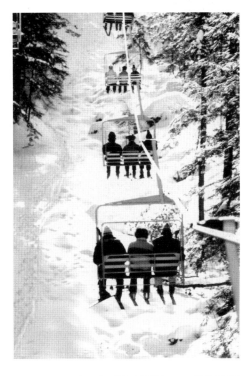

Skiers ride in comfort on the triple chairlift at the Butternut Basin ski area. Chairlifts eventually replaced most rope tows and T-bars as the workhorses of ski lifts. These lifts evolved from prewar singles, to postwar doubles, to triples and quads. Today there is a six-seater lift in operation at the Jiminy Peak Mountain Resort. (Courtesy Cal Conniff.)

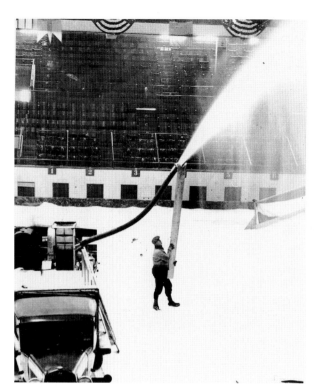

Interested Boston city dwellers frequented the Boston Garden arena in the ski preseason to see the latest equipment, gadgets, and fashions. They also came to see the exhibitions on snow. Hundreds of tons of crushed ice were tossed into a pulverizing machine and then sprayed onto the slide and arena floor. (Courtesy New England Ski Museum.)

The Winter Sports House
of New England

ESTABLISHED 1901
INCORPORATED 1927

G. S. Sprague Company
Sporting Goods
132 FEDERAL STREET
BOSTON

It is difficult to imagine now that ski jumping was the very top of the sport, when Sprague put out its winter sports price list in 1927. Besides skates, snowshoes, and toboggans, Sprague could supply ski breeches ($9 and $15), ski boots ($8.50 to $14), seven types of poles ($2 to $7), seven different bindings ($2.75 to $6) and three manufacturers' skis ranging in length from four to eight feet ($1 to $18 for a racing pair). (Courtesy E. John B. Allen.)

This impressive brochure cover advertises the YMCA's rope-tow area, abutting West Springfield. From 1962 until the mid-1970s, YMCA members paid $1 (their guests $2.50) to ski the 200 foot vertical. Night skiing, instruction, and a patrol were available seven days a week, conditions permitting. (Courtesy New England Ski Museum.)

Carroll Reed grew up in Roslindale and worked for the John Hancock Insurance Company while attending night school at Boston University. This photograph was taken in 1936 when he was making a name for himself retailing high-end clothing for skiers; he later expanded it into a successful mail-order business. Reed was also responsible for bringing Austrian instructor Benno Rybizka to New Hampshire. (Courtesy New England Ski Museum.)

Indoor ski schools, also called dry-land instruction courses, were common in the fall at YMCAs around the state. They were especially well attended in the urban centers. At the Pittsfield YMCA in 1937, two well-known instructors, Joe Aspinall (left) and Larry Bartlett, show the proper form of a snowplow while dressed to perfection. (Courtesy New England Ski Museum.)

Jack Tilley, B. B. Steffanson, Ray Lester, Andy Heuttner, and Hank Furman were volunteer ski patrollers for the Springfield Ski Club at the Blandford ski area in 1946. Although the National Ski Patrol System had been founded in 1938, many postwar areas still relied on volunteers, who attended courses and practiced first aid based on the Red Cross manual. Notice that there is no uniform; Steffanson has a patch and Furman has an armband. (Courtesy Paul Bousquet.)

THOUSANDS ON SKIS

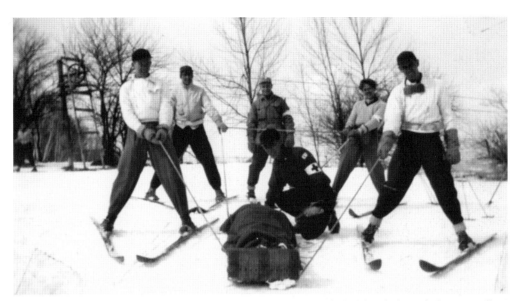

Training day for the volunteer ski patrol at Bousquet's included book knowledge as well as the practical skill of bringing an injured skier off the mountain. Sleds were often make-shift toboggans, and in an era when not every one had steel edges, four patrollers were evidently needed to bring this unfortunate down. (Courtesy Paul Bousquet.)

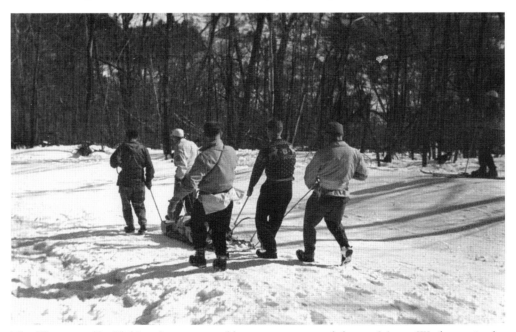

The Worcester Ski Club's volunteer patrol brings in an injured skier at Mount Wachusett in the early 1950s. With the sophistication of today's equipment—light yet stable toboggans with drag chains in front—one patrolman can bring an injured skier down alone. Some 50 years ago, it was thought prudent to bring the victim down by foot with the assistance of five men. (Courtesy New England Ski Museum.)

SKIING IN MASSACHUSETTS

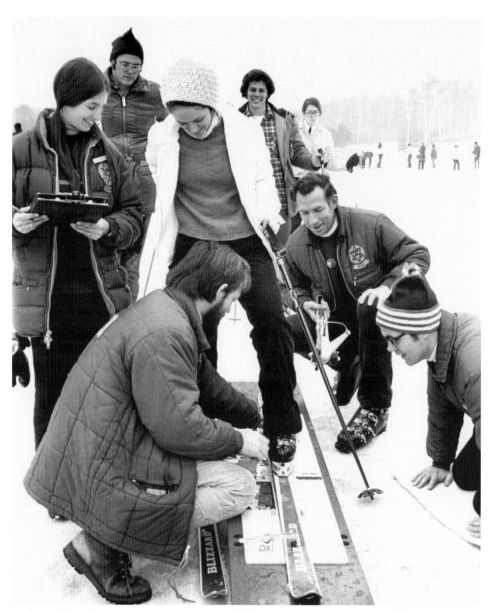

As Alpine skiing became prominent in the 1930s, injury rates increased. The safety binding helped to curb this increase. Estimates immediately before the war suggested that about 10 percent of all skiers were injured during a season. After World War II, not only were there many more people on the slopes, but it was bad publicity for ski areas to have a reputation for injury. Legal costs mounted. But how safe was safe? In the 1950s, thirty-five release-toe bindings were on the market. In 1961, ski brakes were introduced. The National Ski Areas Association became deeply involved in safety education programs, and the National Ski Patrol took the lead in promoting free safety binding release checks, performed here by the local Bousquet patrol under the supervision of Huck Finn, a director of the National Ski Patrol Eastern Division. (Courtesy Paul Bousquet.)

THOUSANDS ON SKIS

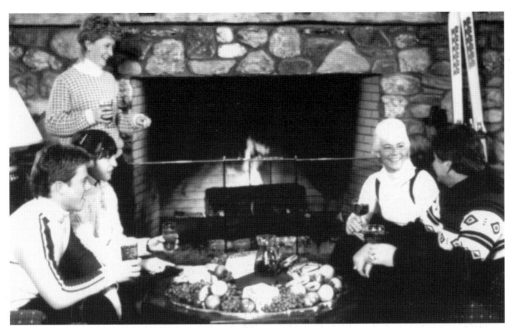

Skiing was not only about technique and schusses, T-bars and races; it was also about après-ski. The image of a blazing fire, a loaded table, glasses of hot–buttered rum, and handsome vacationers decked out in the latest ski wear was another idea of the ski world. These skiers have stories to tell about the runs they managed earlier. A wonderful Jiminy Peak day turns into evening. (Courtesy Randy and Ida Trabold Collection, Massachusetts College of Liberal Arts.)

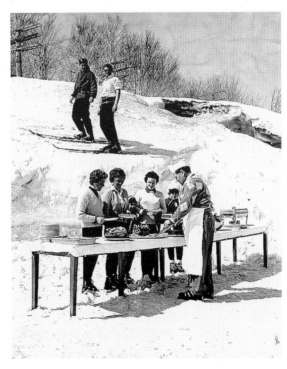

Another spring attraction was the alfresco lunch. Spring skiing in shirt sleeves ended in the outdoor lineup for a cooked buffet lunch. Social chatter over the special meal under an umbrella-shaded table added to the ambience. The chef is in ski boots too—a sure sign that Catamount is an authentic ski community. (Courtesy Randy and Ida Trabold Collection, Massachusetts College of Liberal Arts.)

SKI DINNER

APRIL 27, 1934.

MENU

Cocktail de Red Sohm

Shredded Sealskins

Skiing Hazards in Miniature

Broiled Amstutz Chicken
with Mix Bratlies

Pomme de Terre de Sitzplatz
Tonka·Bean Poles on Toast
with melted Fyk

Breakable Crusts and Medium Ostbye

Slalom

Paraffin with Skare Sauce
and Waxed Cork

Klister au Carbon Tetrachloride

Canned Energy

Bathtubs

At the AMC's annual après-ski dinner, all members would instantly recognize what was on the menu: Cocktail de Red Sohm (Austrian Viktor Sohm's wax); Broiled Amstutz chicken with mixed Bratlies (Walter Amstutz was one of the leading early Swiss downhillers and slalom promoters, and Bratlies were Norwegian waxes); Pomme de Terre de Sitzplatz (holes skiers made when they fell, also called Sitzmarks); Tonka Bean Poles on Toast with melted Fyk (bamboo poles with Fyk, another Norwegian wax); Breakable Crusts and Medium Ostbye (ski conditions and arguably the most well-known Norwegian wax, patented in 1913); skare sauce and waxed cork (wax for cold snow, often blue in color, which was rubbed on and in the ski's base with the cork); Klister (yet another wax); and a dessert of Bathtubs (depressions much larger than Sitzmarks that skiers made when they fell). (Courtesy New England Ski Museum.)

<div align="center">

6

THE APPEAL OF RACING

</div>

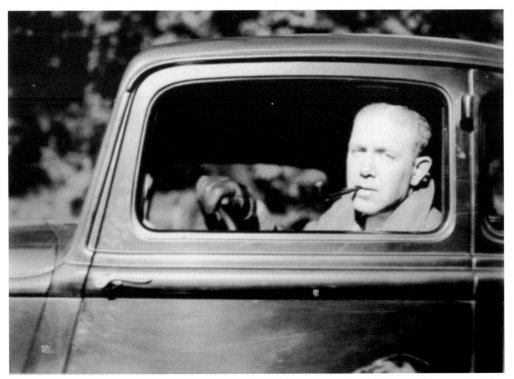

Charlie Parker, the designer of the Thunderbolt trail on Mount Greylock, was photographed by Christine Reid in 1933, when he served as the caretaker of Bascom Lodge. The structure was built on the summit of Mount Greylock by the CCC. An avid skier, Parker designed the trail to descend the east side of the mountain and end at the Thiel Farm in Adams. (Courtesy New England Ski Museum.)

Compare this smooth slope of the 1980s used for grass skiing with the earlier CCC cut trails. In the 1930s, skiing on pine needles received instant recognition before fading quickly. However, grass skiing, invented in 1966 in Germany, is a recognized Fédération Internationale de Ski (FIS) sport. In the downhill schuss position on a perfect slope at Mount Tom, these two skiers are on the caterpillar-like tracks and carry regular poles. In the 1980s, summertime grass skiing was a valid training method. (Courtesy Cal Conniff.)

THE APPEAL OF RACING

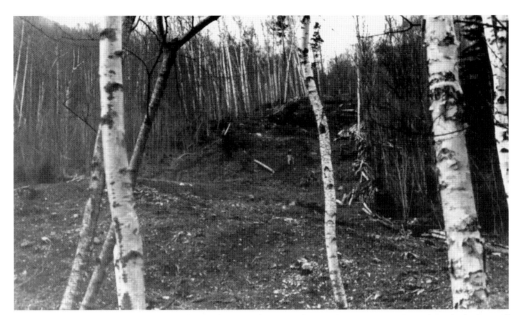

Photographer Christine Reid took this photograph of the construction of the Thunderbolt trail on November 5, 1934. Early ski trails tended to be narrow because they were designed by and for good skiers. The Thunderbolt was a Class A racing trail. With its combination of steepness and narrowness, it was comparable to the Taft trail on Cannon Mountain in New Hampshire. (Courtesy New England Ski Museum.)

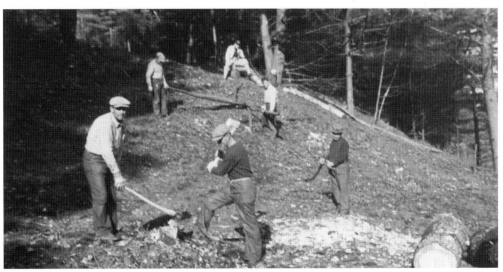

In 1934, CCC workers cut the ski trail on Mount Grace, just out of Warwick in central Massachusetts, without the aid of heavy machinery. The CCC disbanded at the outbreak of World War II. Many of the outdoor structures remain in use to this day, and some of the trails can still be seen. A short rope tow, the remains of which still exist, served about 200 feet of vertical ski running. Mount Grace is one of 42 "lost" ski areas in central Massachusetts listed on the Internet in the New England Lost Ski Areas Project. (Courtesy New England Ski Museum.)

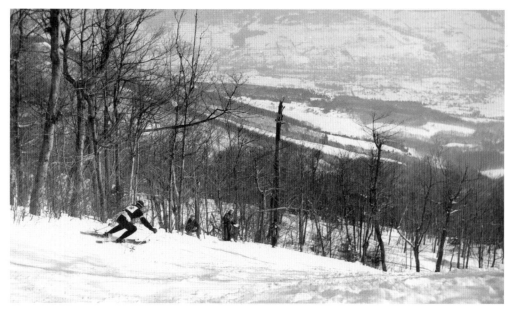

The Thunderbolt trail was in perfect condition for the United States Eastern Amateur Ski Association's downhill championship in 1948. This runner, showing good *Vorlage*, or "forward lean," is in full control as he takes the corner wide and sure. The photograph was published in the *American Ski Annual*. (Courtesy New England Ski Museum.)

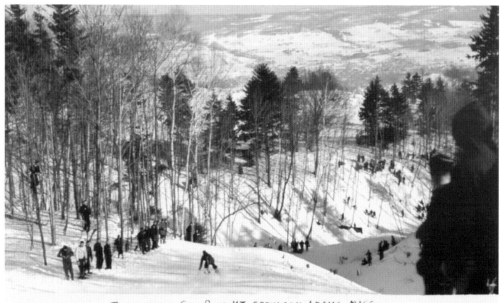

THUNDERBOLT SKI RUN MT. GREYLOCK ADAMS, MASS.

As the state's only Class A racing trail, the Thunderbolt had an aura about it, and any skier beyond the novice phase felt that he had to test himself by running it. When "Old Man Winter" commented that it was "almost as difficult as the Taft," Bart Hendricks would have none of that; he replied, "It is a good deal more difficult." (Courtesy New England Ski Museum.)

THE APPEAL OF RACING

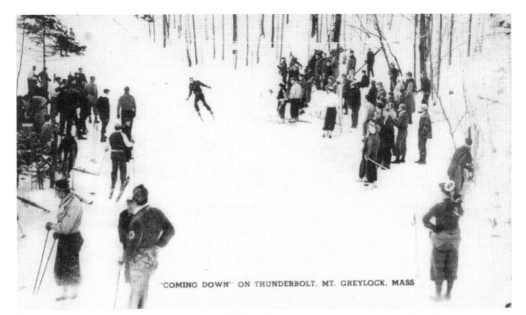

"COMING DOWN" ON THUNDERBOLT, MT. GREYLOCK, MASS

The standard of skiing was low in the 1930s. Ski schools were patronized by the real novice. Once beyond the basics, he would learn from his fellow club members. The style of skiing performed on the state's most famous run shows that there is much to be learned by the skier and the spectators. (Courtesy E. John B. Allen.)

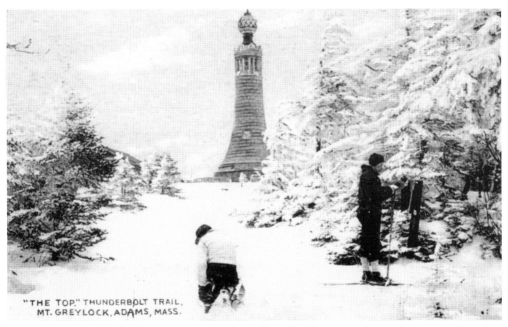

"THE TOP," THUNDERBOLT TRAIL, MT. GREYLOCK, ADAMS, MASS.

The top of the Thunderbolt was not steep, but when the skier moved into the cornered pitches such as the one here, he would pick up speed and just hope he could hold on. Most racers fell, causing the difference between the winning time and ending time to often be a number of minutes. (Courtesy E. John B. Allen.)

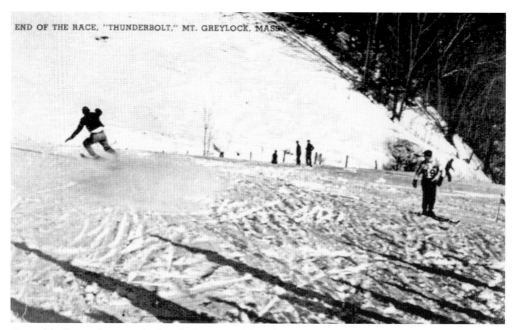

One of the last wide swings before the bottom of the Thunderbolt has been crossed so many times that there is not a track to be seen. "Carving" a turn was simply impossible without metal edges. When steel edges were added, the carved turn required more skill and coordination at speed—something the majority of skiers were unable to master immediately. (Courtesy E. John B. Allen.)

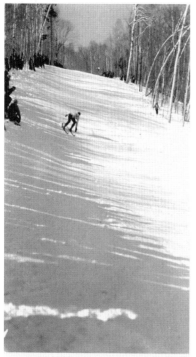

Tom Clement of Williams College looks a little unsteady on the Thunderbolt. His legs are nicely apart, but his balance is off kilter. Dropping nearly 1,800 feet in just over a mile, the trail had grades of over 25 percent in places. Clement was good enough to enter the Olympic trials in 1935, but he ended 19th at 1 minute 23 seconds behind the winner. (Courtesy New England Ski Museum.)

THE APPEAL OF RACING

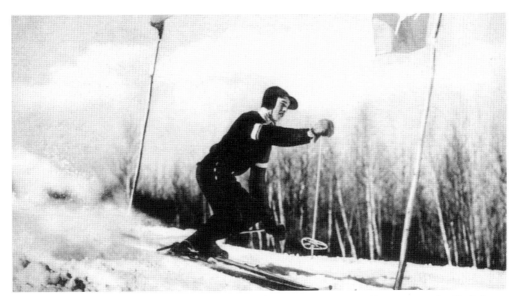

Verne Goodwin of Pittsfield shows his form while running a gate at Eastover in the Berkshires in 1949. The Middlebury College ski team ace was chosen for the Winter Olympics in 1952 after a sensational 1951 season, but he injured his ankle and could not compete at the Oslo Games. Heidi Voelker, another Pittsfield native, was a three-time Olympian in 1988, 1992, and 1994. (Courtesy E. John B. Allen.)

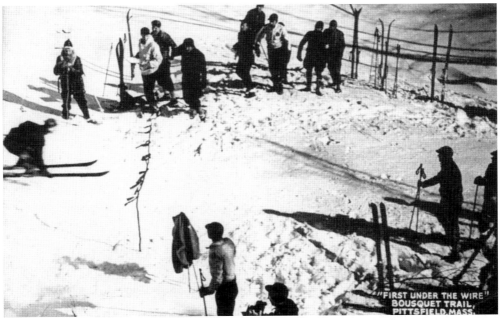

No racer would be made to finish like this today. The expression "first under the wire" stems from the race horse world, where judges had a wire high above the finish line to help gauge winners in close contests. Here at Bousquet's, the racer actually had to duck under the finishing line hung with flags. (Courtesy E. John B. Allen.)

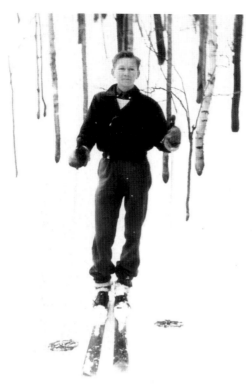

Rudy Konieczny was a ski hero in the mill town of Adams. In 1937, he was considered the hometown threat to the best skiers in the nation. He won many races. As a member of the 10th Mountain Division, he was killed in action in Italy. In 1999, former Thunderbolt racers and 10th Mountain veterans met atop Mount Greylock to dedicate a shelter to their fallen comrade and skier. (Courtesy Cal Conniff.)

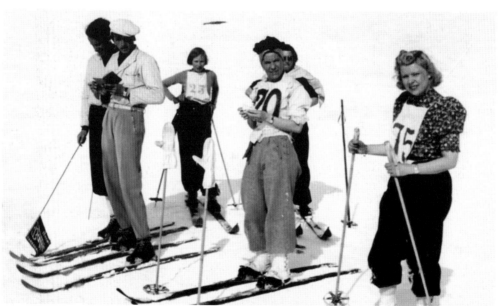

Could these be Olympic hopefuls for the 1930s? Not exactly. Here the amateur quality of racing is obvious, as there are no uniforms and certainly no thought to cut down on wind. No. 75 does not even know the correct way to put her hands in the loops of the poles. This is probably a ski school "race," with the instructor—so elegantly attired—all set to critique the girls after they have shown what they have learned. (Courtesy E. John B. Allen.)

THE APPEAL OF RACING

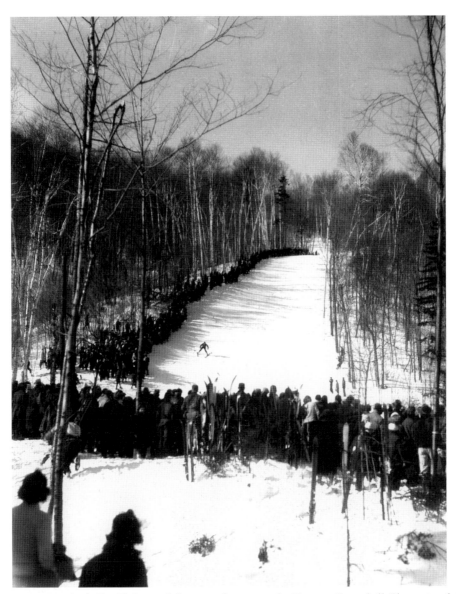

The Mount Greylock Ski Club stood the test of running the Eastern Downhill Championship of 1936 on the new Thunderbolt trail. Dartmouth star Dick Durrance—well known all over New England—won in two and a half minutes in spite of one fall. An estimated 5,000 spectators were on hand. This view depicts the slope above the fearsome final schuss for the finish, yet even here the racer is in a wide snowplow. By 1936, there were four types of competitors. The first were the *Kanonen*, which included the big guns, the Dartmouth downhillers, and a few other collegiate and Boston club aces. Then came the also-rans, men who enjoyed the camaraderie of the racing fraternity and perhaps occasionally might place 10th or so. After them were the hopefuls, people who went in for club races on a semi-serious basis. Finally there were the dubs, beginners who had improved enough to enter a ski school race. The first two categories were Thunderbolt race competitors. (Courtesy Cal Conniff.)

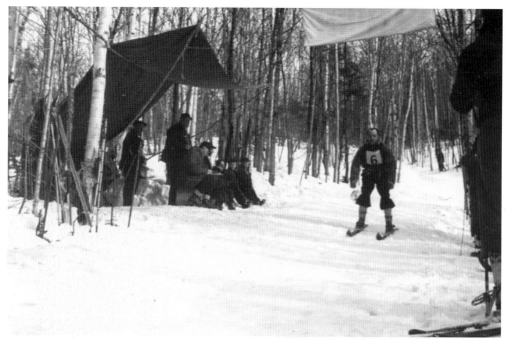

Sam Wakeman of the Ski Club Hochgebirge of Boston won the AMC's race in March 1936. He finished 14th in the Olympic trials. In 1936 and again in 1939, Wakeman was a member of the winning Hochie ski club for its own Challenge Cup, which in these years was often won by the Dartmouth Outing Club. (Courtesy New England Ski Museum.)

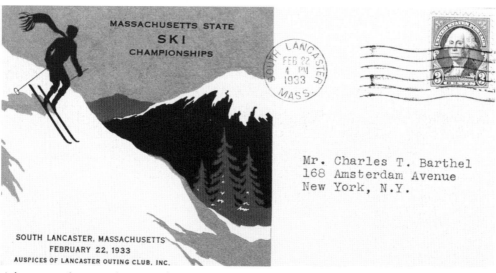

Advertising the state championships in 1933 was done in many ways. The figure on the envelope gives the impression of recreational downhill skiing with enough scarf to slow anybody down. In fact, the championship was in jumping, and the favored Massachusetts hometown boy and 1932 Olympian John Ericksen was the winner. Not to be outdone, some Ski Club Hochgebirge members, downhill experts, entered the competition too. (Courtesy E. John B. Allen.)

Marie O'Connell Chapman, pictured at the finish line in 1949, was one of the first women to compete in a challenging Thunderbolt downhill. The new breed of good club women racers like Chapman was unafraid of the steepness of Class A trails. (Courtesy Cal Conniff.)

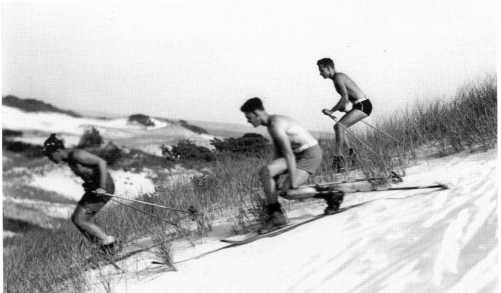

Speed on snow, and if one cannot have snow, then speed on sand. In this 1935 image, two Boston skiers are led by Pierpoint Fish (wearing hat), self-styled instructor of sand skiing on Cape Cod. It does not seem to matter that one of the skiers is making a telemark turn, something that the Arlberg technique had virtually eliminated from the Massachusetts ski terrain. (Courtesy New England Ski Museum.)

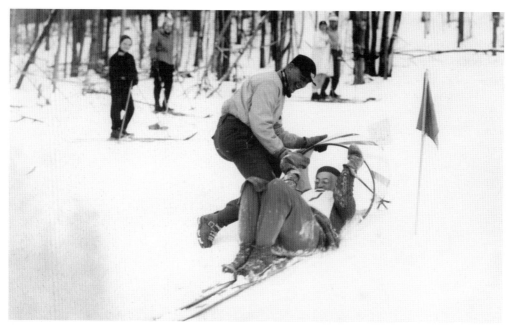

Club skiing was not always organizational meetings, technical turns, and race results. Going through the barrel on seven-foot skis in 1948 is the president of the North Adams Ski Club, Hugh Defalco. The annual obstacle race, one of the most popular events, added to club spirit. (Courtesy New England Ski Museum.)

In 1936, the White Mountain Ski Runners of Boston offered the Webber Bowl for an annual ski race. The bowl was an exact replica of one made by Paul Revere in 1768. Challenge bowls and cups were highly prized in the pre–World War II years; this was the era of amateur skiing. (Courtesy New England Ski Museum.)

THE APPEAL OF RACING

Faith Donaldson of Concord raced with America's first international team to compete in Europe. At the 1935 Fédération Internationale de Ski (FIS) meet held in Mürren, Switzerland, she placed 23rd in both slalom and downhill. Arnold Lunn—British arbiter of Alpine competitions and always a friend of American skiers—judged that "she ran very nicely for a first FIS." Later she appeared in *Life* at Sun Valley in 1937. (Courtesy New England Ski Museum.)

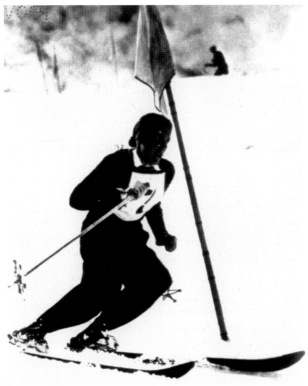

Beverly Farms's Marion McKean made the 1936 Olympic team but her best season was 1938. She finished 10th at Mégève, 2nd in downhill and slalom at the Austrian Tirol Championships, 10th and 11th in downhill and slalom at the International Sports Week in Garmisch-Partenkirchen, 3rd on the Parsenn, 1st in the slalom of the Titulescu Challenge Cup at St. Moritz, and 4th in the Swiss Championships at Wengen. (Courtesy New England Ski Museum.)

Adams Carter of Milton and Harvard, photographed by Christine Reid in 1936, had a distinguished skiing and mountaineering career. He was part of the American team that won the Newell Bent Junior Memorial Trophy (presented by the Harvard class of 1933 as a perpetual challenge cup for all American skiing nations) in Chile in July 1937. (Courtesy New England Ski Museum.)

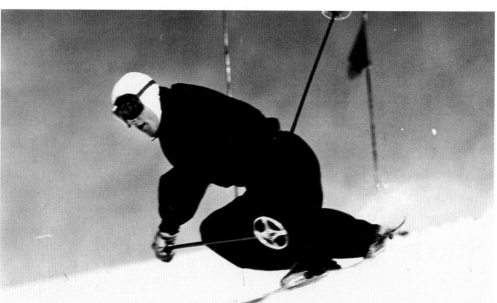

Massachusetts has produced several world-class racers over the years. George Macomber of West Newton, after a combined third in the Olympic trials, represented the United States at the 1948 Games while a student at the Massachusetts Institute of Technology. After excellent seasons in 1949 and 1950 (first in the nationals, Eastern downhill, Gibson Trophy, and Webber Cup), he was chosen for the 1952 Olympics. (Courtesy New England Ski Museum.)

THE APPEAL OF RACING

GETTING OUTFITTED

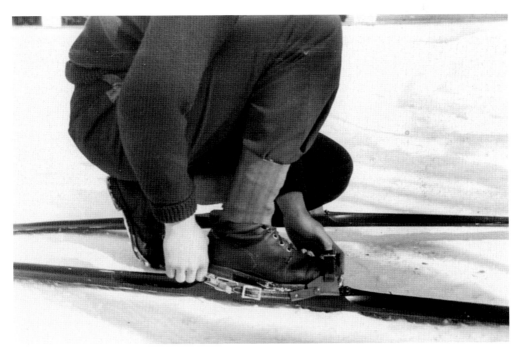

With brand-new skis, the modern boot of 1932 is held tightly, the binding's lever stretching around to keep the heel firmly on the ski. Wearing special ski pants and sweater, this Harvard man is nevertheless using pieces of old rubber inner tubes for gaiters. (Courtesy New England Ski Museum.)

SKIING

CLOTHING to prevent chills

EQUIPMENT to provide thrills

Hickory ridge top Slalom, Touring and Down-hill skis	**$16**
Ash, edge grain, ridge top	**$12**
Hard rock maple, ridge top	**$9**
Hickory, flat-top Touring	**$9.50**
Ash, edge grain	**$7.50, $8**
Maple, hard rock, 5ft. to 7½ ft.	**$4 to $6.50**
Pine, 4ft. to 6½ ft.	**$1.25 to $3.25**
Ski poles **$2.75 to $5** pr. Youth's	**$1.50** pr.
Waxes 25c to 50c Bindings	**$3 to $7.50**
Ski Boots **$5.85 to $10** Ski Socks	**75c to $1.75**
Wind-proof Parkas	**$5.** up
Ski Breeches **$5. to $10.** Ski Caps	**$1.75**

Shoe Skates Hockey Tube.... 5⁴⁵

Other Hockey Shoe Skates	**$8.95 to $24.50**
Figure Shoe Skates	**$8.95 to $27.35**
Snow Shoes	**$3.85 to $12**
Snow Shoe Sandals	**$1.50 and $1.75**

SKATES SHARPENED—Regular Grind, 25c; Oil Finish, 50c.
SKIS RECONDITIONED

For authentic Ski clothing and equipment — come to Wright & Ditson

Wright & Ditson

344 Washington St., Boston
Tel. LIBerty 2733

One of a number of department stores in Boston, Wright and Ditson stocked winter sports equipment. Hickory from the American South was the wood of choice for skis, with a correspondingly higher price than local ash, maple, and pine. Bindings, poles, waxes, socks, boots, trousers—ski breeches as they were called—parkas, and caps were available. One could be completely outfitted in 1938 for anywhere from $25 up to $75. (Courtesy New England Ski Museum.)

Jordan Marsh chose to use Rudolf Friedrich in a jump turn for its advertising. In case the reader did not understand, the store added that he was "our instructor direct from the Alps" for its White House Inn ski shop at the Boston Garden show. Friedrich would advise on correct clothes, just as he would on correct "Christys" (as the Christiania turn was called), and give lessons on the shop's second-floor ski slide. (Courtesy New England Ski Museum.)

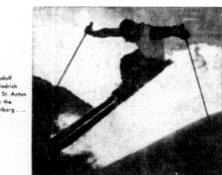

Rudolf Friedrich at St. Anton on the Arlberg . . .

Rudolf Friedrich

OUR SKI INSTRUCTOR DIRECT FROM THE AUSTRIAN ALPS—WILL EXHIBIT AT THE

National Winter Sports Exposition and Ski Tournament

In Boston Garden—November 29-December 6

When not going off the steep end of the great indoor slide during the Ski competitions at the Garden Snow Sports Show, Mr. Friedrich will be in our "White Horse Inn" Ski Shop there, to give you tips on everything from correct Christys to correct clothes to wear when making them. Enroll for Mr. Friedrich's classes for Ski Gymnastics ($1 each lesson) at our own indoor ski slide on the second floor, main store—or at our Ski Shop in Boston Garden.

Visit "White Horse Inn" in our Tyrolean Village, Second Floor—Main Store.

Visit Jordan's "White Horse Inn" Ski Shop at the Boston Garden Winter Sports Show.

Six shops for Snow Sports—wearables for tots, girls, boys, men, women and all the equipment for everyone!

Oscar Hambro, a Norwegian who had first immigrated to Canada, set up shop in Boston in 1926, starting one of two specialty ski stores in town. His shop resembled a club, more like a ski fraternity whose members swapped tales by a roaring fire in the Norwegian-style log cabin. By 1937, he had opened up another store in New York City, as well as a factory to make skis in New Hampshire. Besides his own skis, he sold Norwegian and Swiss models and others by U.S. manufacturers, a variety of ski bindings including the favored Kandahar with its spring heel as well as Bildsteins, and boots both imported and domestic. Bass and L. L. Bean were particularly competitive, with Bass providing the boots for the 1936 Olympic squad. (Courtesy New England Ski Museum.)

James W. Brine's Summer Street shop offered competition to Hambro, Osborne, Proctor, and B. Johansen. The fact that there were four specialty stores in Boston in the late 1930s says much about the growth of skiing as a sport and a business. By 1940, skiing had become the fastest growing recreational sport in America; estimates put the number of people on skis between one and three million. (Courtesy New England Ski Museum.)

One of the more usual services supplied by ski shops in the early 1930s was screwing steel edges on to older skis. An Austrian had patented the steel edge in 1928, and by the time this photograph was taken in 1934 at Hambro's, manufacturers were turning out steel-edged skis. However, many skiers still relied on their old hickories and so had the edges grouted and the new edges screwed on. (Courtesy New England Ski Museum.)

Catalogue and Equipment Manual
"THE WHAT AND WHY OF SKI EQUIPMENT"

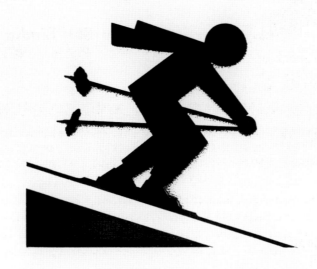

HARVARD COOPERATIVE SOCIETY
HARVARD SQUARE **CAMBRIDGE, MASS.**

SKI SPORT, INC. **144 HIGH STREET** **BOSTON, MASS.**

Ski Sport was a popular ski shop in Boston, largely because it was run by Charley Proctor, Dartmouth graduate and 1928 Olympic team member. There was no better pedigree. Rockwell Stephens, a partner, remembered that when good equipment was hard to find "some people in Boston put up some money for us." There were 8 to 10 stockholders—all skiers—"who decided to take a fling more or less for the hell of it. . . . The nature of the stockholders was such that one of them told us to go to a certain bank and we could probably get a little credit there." The old-boy network was strong in the 1930s. "First choice of the experienced, a safe choice for the beginner" was the slogan for the business, "an organization of skiers, for skiers," one which kept in touch with new trends in Scandinavia and Europe. (Courtesy New England Ski Museum.)

Charles Pierson (center), president of Boston's Ski Club Hochgebirge, with members Tom Dabney (left) and Robert L. Raymond, models—hardly in professional form—the latest Saks Fifth Avenue styles at the bottom of the Thunderbolt trail. It was not above Boston's wealthiest to do this sort of thing in the 1930s; it was rather a lark, in fact. (Courtesy New England Ski Museum.)

In February 1936, Jane Kinsley of Worcester enjoys her new parka, which she had seen at the Boston Garden exhibition. With a fur trim, the jacket had more than a hint of warmth of the north. In fact, snow sometimes balled up on it. No matter; Kinsley would look her best when appearing at après-ski *tée dansant* and *Glühwein* parties. (Courtesy New England Ski Museum.)

In the 1930s, the skiing authority of Norway was put in jeopardy with the arrival of Alpine techniques and the skimeisters to teach them. However, Bjarne Johansen could still rely on "a real Norwegian shop" with the personal attention of a real Norwegian skier to sell his wares in Boston. (Courtesy New England Ski Museum.)

The 1932 Snow Queen of the Pittsfield Winter Carnival, Mary Robbins, wears matching ear muffs and gloves. Look carefully at her skis. These have steel edges attached with screws. Carnival Queens and Snow Train Queens were typical 1930s entertainment. Democratic and republican America loved its make-believe royalty. (Courtesy Randy and Ida Trabold Collection, Massachusetts College of Liberal Arts.)

NATIONAL WINTER SPORTS EXPOSITION
and SKI TOURNAMENT

DECEMBER
5-6-7, 1935

BOSTON GARDEN
NORTH STATION, BOSTON, MASS.

This cover is reproduced by permission, from the August 21st, 1935, issue of MEN'S WEAR—copyright 1935, Fairchild News Service.

The cover of the 1935 Boston Garden exposition pamphlet hits all the right notes. A beautiful New England day provides the backdrop for admirable skating, thrilling ski jumping, daredevil bobsledding, and skiers socializing in the latest colorful outfits by a crackling fire. An Austrian expert from Salzburg, Sig Buchmayr displayed the usual turns and then "gelandesprungs, umsprungs and pole somersaults" at the show. (Courtesy New England Ski Museum.)

Sig Buchmayr shows off his *Quersprung*, a turning terrain jump. He headed the list of downhill skiers at the Boston Garden exposition. Others included Freddie Nachbaur, an American who was once refused a coaching job because he did not have an Austrian accent; Charley Proctor, 1928 U.S. Olympian; and Norwood Cox, just returned from teaching in Europe and about to become the Harvard coach. Hannes Schneider came with two of his instructors, Otto Lang and Benno Rybizka. (Courtesy New England Ski Museum.)

Second Annual

NATIONAL WINTER SPORTS EXPOSITION and SKI TOURNAMENT

BOSTON GARDEN BOSTON, MASS.

OFFICIAL PROGRAM
25c

SIG BUCHMAYR
Photo by Reynolds

NOVEMBER 29 to DECEMBER 6, 1936
Inclusive

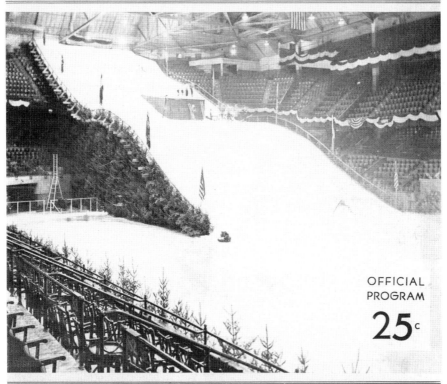

THE BOSTON GARDEN - ARENA

SPORTS-NEWS

A SPORT MAGAZINE WITH DAILY PROGRAM INSERT

VOL. X — No. 3　　　　　　　　　　　　　　　　　　　　1937-1938

OFFICIAL
PROGRAM

25°

THIRD ANNUAL
NATIONAL WINTER SPORTS EXPOSITION
and SKI TOURNAMENT
DECEMBER 1, 2, 3, 4, 5, 1937
AFTERNOON AND EVENING

The program for the 1937 Garden show promoted the usual array of spectacles: dogsled races, fancy skating, style shows, a cross-country race, 11 downhill specialists, 5 Sun Valley skiers, a timed slalom run, and the showbiz of pair and triple jumping and somersaulting. Photographs of fashion, hockey, professional jumpers, midget automobile racing, and Sonja Henie accompanied the text, along with articles on the Boston and Maine snow trains from North Station, a "Let Sanity Prevail" call for safer skiing, and skiing in Maine, New Hampshire, and Sun Valley, Idaho. "Berkshire Invites Skiers" highlighted the Mount Greylock Ski Club of Pittsfield, which was hosting four of five sanctioned races in Massachusetts during the 1937–1938 season. Brodie, Beartown State Forest, Great Barrington, and Mount Wachusett all received notice. (Courtesy New England Ski Museum.)

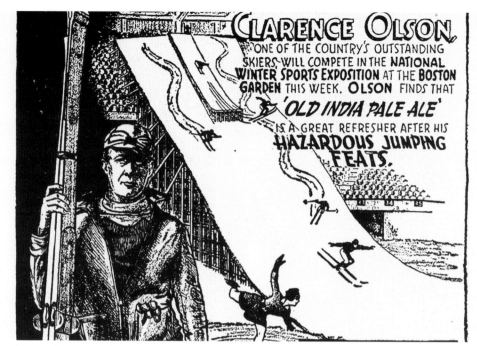

Professional jumper Clarence Olsen, seen here advertising Old India Pale Ale, would be at the Boston Garden show in 1935. Liquor and tobacco firms also promoted their products in the 1930s through the use of prominent skiers like Olsen. Sig Buchmayr skied for Seagrams whiskey, and Camel cigarettes "steadied the nerves" for expert downhillers Hans Thorner and Dick Durrance and jumper Anton Lekang. (Courtesy New England Ski Museum.)

THUNDERBOLT SKI RUN MT. GREYLOCK ADAMS, MASS

Three unidentified nattily dressed skiers stand at the bottom of the Thunderbolt. Note the jacket-parkas come well across the chest and are buttoned; zips are not yet in fashion. Ski pants are tucked into socks, and gaiters go over the top of the boots. Skis are about seven feet long with poles that reach the armpits. (Courtesy New England Ski Museum.)

A great attraction at the 1938 Boston Garden show was Norwegian superstar Sonja Henie, pictured here with Clare Bousquet's son Paul. After an appearance on the Norwegian Olympic team in 1924, she went on to win three consecutive gold medals at the Olympics in 1928, 1932, and 1936, then turned professional, starring in ice capades and films. She became an American citizen in 1941. These Garden exhibitions were a mix of serious promotion of equipment and show business. Skaters were always included. In 1935, "fancy skating" and ice hockey were scheduled; in 1936, speed skating and hockey received publicity through long articles. Then world star Sonja Henie herself came in 1938. Although not a strong skier, Sonja Henie starred in *Sun Valley Serenade* in 1941, with the young Gretchen Fraser as her double in the skiing scenes. (Courtesy Paul Bousquet.)

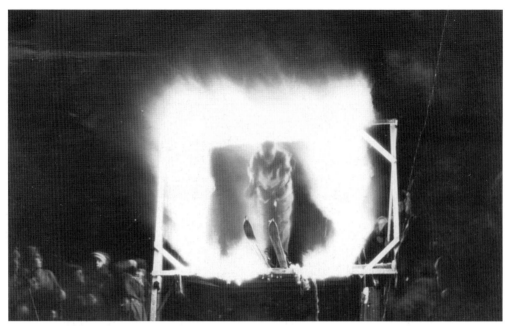

The typical show-biz hype of the Boston Garden show was exemplified by the end-of-jump routine, during which the jumpers leaped through a hoop of fire like this one. What amazed the arena crowd in 1935 had become disappointing by 1939, as crowds made for the exits even before the finale had taken place. (Courtesy E. John B. Allen.)

The Original
New England
Ski Feature

Originated,
Edited and Read
by Ski Enthusiasts

"OLD MAN·WINTER"

The live, authoritative weekly feature on which New England skiers have depended for six years. Read "Old Man Winter" for authentic up-to-the-minute information on weather and snow conditions, trails, tows, competitions, club meetings, and other Winter Sports events. Follow the news and advertising for latest dope on new equipment, transportation, and places to go. The active skier finds "Old Man Winter" an essential to his season's enjoyment.

75¢ for 15 consecutive issues, single copies 5¢ by mail

Published Every Friday
November 26 through March 24
Only in the

Boston Evening Transcript

Boston Massachusetts

Benjamin Bowker's "Old Man Winter" was one of the most popular Friday features of the *Boston Evening Transcript*. The ski journalist—a new profession in the 1930s—taught the novice skier about the sport, including the necessary clothing and equipment, suitability of snow train destinations, even about technique. Race results and fashion notes added a social touch. Started in 1931, "Old Man Winter" became a must-read of the weekly skiing news around Boston. (Courtesy New England Ski Museum.)

Two important ski photographers from Massachusetts, seen here in 1937, were Harold Orne (left) of Melrose and Charles Trask, who lived in various towns. They were photographed with their (by today's comparison) unwieldy and weighty cameras, the news photographers' standby, the Speed Graphic Graflex. Their lenses caught the essence of the 1930s ski scene in Massachusetts and the rest of New England. (Courtesy New England Ski Museum.)

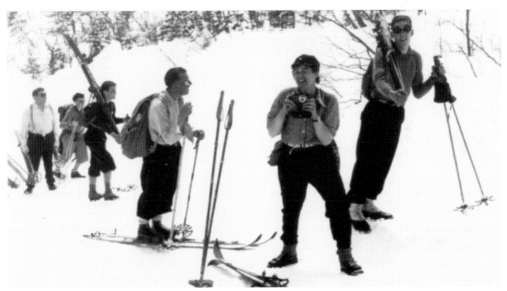

Christine Reid, with great Alpine experience in the United States, Canada, and Europe, photographed a wide variety of ski happenings with a much smaller Leica camera. She was a reporter and photographer, article writer, and Brookline's most prominent ski publicist. Her colleague Harold Orne took this photograph in 1937. (Courtesy New England Ski Museum.)

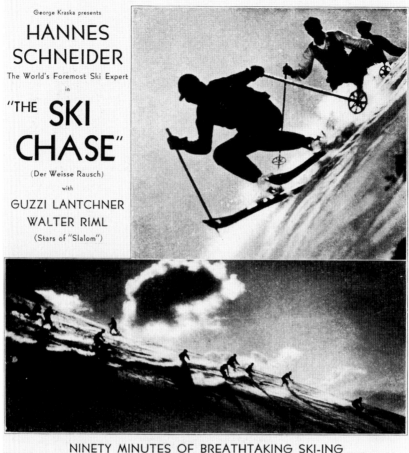

THE GREATEST SKI FILM EVER MADE!

George Kraska presents

HANNES SCHNEIDER

The World's Foremost Ski Expert

in

"THE SKI CHASE"

(Der Weisse Rausch)

with

GUZZI LANTCHNER
WALTER RIML

(Stars of "Slalom")

NINETY MINUTES OF BREATHTAKING SKI-ING
Foolhardy and Gay
FILMED IN THE AUSTRIAN TYROL

AMERICAN PREMIERE
Sunday, December 6, 1936
CONTINUOUS DAILY AND SUNDAY I TO II P. M.

FINE ARTS THEATRE
Direction George Kraska

MASSACHUSETTS AVENUE AT NORWAY STREET. BOSTON. MASS. — KENMORE 5584 - 3540

This 1936 flyer promotes the American premiere in Boston of Hannes Schneider skiing in *Der weisse Rausch*, now translated as *The Ski Chase*. The advertisement shows just how important the name of Schneider had become, as filmmaker Arnold Fanck is not even mentioned. By now, Schneider was the world's best-known skimeister and his protégés, members of the St. Anton ski school, were dotted around the country. Films like these, set in spectacular and pristine Alpine terrain, elevated skiing to a fantasy and ideal beyond the reach of the audience, which marveled just as much at the fairyland high mountain landscapes as the flawless ski turns swishing the powder up and around in aesthetic plumes. Skiing was akin to ballet—not exercise or merely sport, as one of his instructors put it, but "revelation for body and soul." (Courtesy New England Ski Museum.)

TO EUROPE
for
Winter Sports

LLOYD SKI BOATS

Europa
JAN. 15 and FEB. 5

Bremen
JAN. 22

Midnights from New York
Morning arrivals at

CHERBOURG

SOUTHAMPTON

BREMEN

Carrying
CABIN CLASS
TOURIST CLASS
THIRD CLASS

Ski Boats to Europe

Hamburg-American Line
North German Lloyd

Book Early
YOUR TRAVEL AGENT, or

Hapag
SKI BOATS

Hansa
JAN. 13

Deutschland
JANUARY 20

St. Louis . Jan. 27

Wednesday Midnights to
CHERBOURG
SOUTHAMPTON
HAMBURG

This Folder . . .
Contains a full program of the major
Winter Sports held this season through-
out Europe Information, also on
reaching the sport centers . . rates and
specially arranged tours. Copy is, of
course, free. Call or send for Your Copy.

Hamburg-American Line • North German Lloyd

252 BOYLSTON STREET, BOSTON
Telephone : COMmonwealth 1155

At the first Boston Sports Exposition, the emphasis had been on equipment and solid advice. In 1936, ski venues were being advertised, and by 1937, skis, boots, and bindings were not so much to the fore as travel and hotel accommodation. International firms were represented such as the German and Swiss railroads, Norwegian and Finnish industries, and the Austrian Tourist Bureau. This advertisement highlights the globalization of the ski sport in the late 1930s. However much Massachusetts entrepreneurs and the state itself might have improved the skiing facilities, the goal of the better-off in society was to ski in Europe. The Alps offered such vast, virgin terrain above tree line, spectacularly placed villages, mountain railways, and *Dirndls*, *Bier*, and *Gemütlichkeit*. Massachusetts could hardly compete. Of course, one had to have disposable wealth; 42 percent of the Hochies had skied in Europe by 1938. (Courtesy New England Ski Museum.)

Select Motion Views

with Discriptive Lectures

WINTER IN THE WHITE MOUNTAINS
and other subjects

MOTION PICTURE ENTERTAINMENT
For Discriminating Audiences

Specially Prepared by
WINSTON H. POTE
PHOTOGRAPHER
Swampscott, Mass.

Assisted by
JOHN C. WELSH
LECTURER
Lynn Mass.

Under direction of
THE WHITE ENTERTAINMENT BUREAU
100 Boylston Street Boston, Mass.

Doyen of New England ski photographer Winston Pote, a Swampscott native, brought skiing alive in the 1930s with his still images, movies, and lectures. Pote also used a Speed Graphic Graflex camera. During World War II, he became photographer of the 10th Mountain Division, America's ski troops. He filmed the division's activities on the home front, training in Colorado. (Courtesy New England Ski Museum.)

John Jay of Williamstown took his popular ski movies on an increasingly wide-ranging circuit of North American cities, where they became a preseason institution from the 1950s to the 1970s. The magnificence of the scenes he shot was paralleled by the equally stirring skiing. His shows were always presented in person, with flair and droll commentary. (Courtesy New England Ski Museum.)

In 1959, Cal Conniff hosted Roger Peabody, executive director of the United States Eastern Amateur Ski Association, on *Skiers Corner* on Springfield's television station WWLP, Channel 22. Conniff, ex-racer, general manager of Mount Tom, and director of the National Ski Areas Association, was among the earliest of ski television personalities in Massachusetts. (Courtesy New England Ski Museum.)

Promotional hype was not always successful at Brodie Mountain, known as Kelly's Irish Alps after flamboyant owner Jim Kelly. On St. Patrick's Day, green snow was not appreciated by skiers who fell; it stained their clothes. Still, Brodie, with its 1,250-foot vertical and average snowfall of 85 inches, could boast good skiing. Subsequently bought by Jiminy Peak, it has been turned into a snow-tubing haven. (Courtesy New England Ski Museum.)

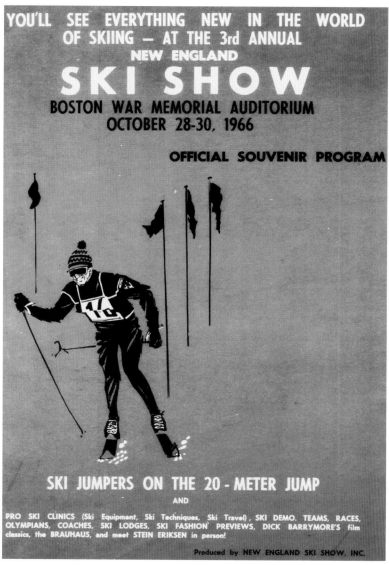

YOU'LL SEE EVERYTHING NEW IN THE WORLD OF SKIING — AT THE 3rd ANNUAL
NEW ENGLAND
SKI SHOW
BOSTON WAR MEMORIAL AUDITORIUM
OCTOBER 28-30, 1966

OFFICIAL SOUVENIR PROGRAM

SKI JUMPERS ON THE 20 - METER JUMP
AND
PRO SKI CLINICS (Ski Equipment, Ski Techniques, Ski Travel), SKI DEMO. TEAMS, RACES, OLYMPIANS, COACHES, SKI LODGES, SKI FASHION PREVIEWS, DICK BARRYMORE'S film classics, the BRAUHAUS, and meet STEIN ERIKSEN in person!

Produced by NEW ENGLAND SKI SHOW, INC.

The New England Ski Shows were initiated again in the 1960s and held in Boston's War Memorial Auditorium. These were quite similar to the earlier shows at the Garden in the 1930s, as they included equipment, advertisement for holidays, films, and, in 1966, the personal appearances of Stein Eriksen and Anderl Molterer. Eriksen had made his name in the 1952 Olympics on his home ground outside Oslo, Norway, and then had taught at various U.S. ski resorts. His Stein turns were famous, and so was the somersaulting he performed daily. If any one skier were to be identified in this country, it would be Eriksen. Molterer, "the Blitz from Kitz," was an 11-time Austrian champion and 4-time winner of the Hahnenkamm and the Gornergrat. He won the Harriman Cup, the Internationals at Stowe, and the North American Championships in Vail. Molterer was also winning on the professional circuit. If all that competition proved a bit frightening, the editor added, "In case you are a purely recreational skier, fear not. He skis for fun too." (Courtesy New England Ski Museum.)

SKIING GOES HIGH TECH

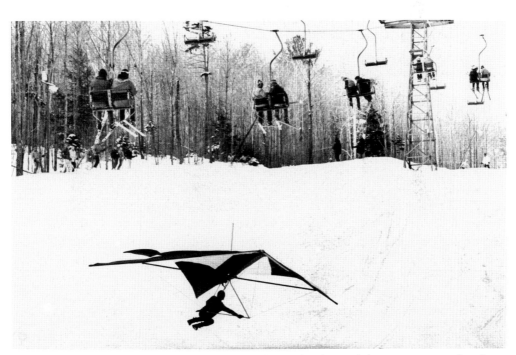

Not what one would expect to find on a ski slope, this hang glider swoops over the slopes of Brodie Mountain in New Ashford, much to the delight of the ski lift riders. After the oil embargo of 1973, which made for a declining skiing population, area operators searched for new ways to attract skiers to their ski centers. (Courtesy New England Ski Museum.)

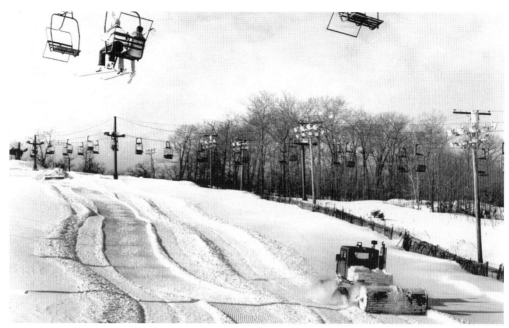

Before the arrival of grooming vehicles, skiers could earn a lift ticket by packing out the snow with their skis. After World War II, conditioning and grooming snow to create a smooth surface slowly became expected. The roller worked well on powdery surfaces. Today's operators would never be allowed to leave a surface with berms like these. (Courtesy Cal Conniff.)

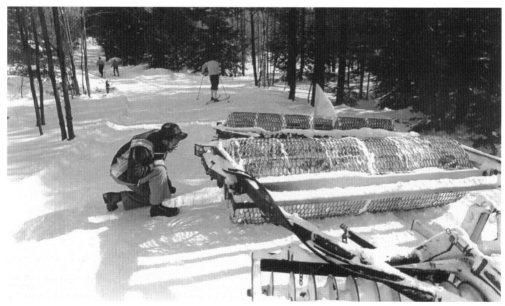

Once the snow was smoothed out, the powder maker would fluff up the surface prior to setting tracks such as these at the Northfield Mountain Ski Touring Center. Increasing numbers of skiers took to cross-country after the oil embargo of 1973, and they were willing to pay for the prepared tracks of a center rather than go off into the woods on old logging trails. (Courtesy Cal Conniff.)

SKIING GOES HIGH TECH

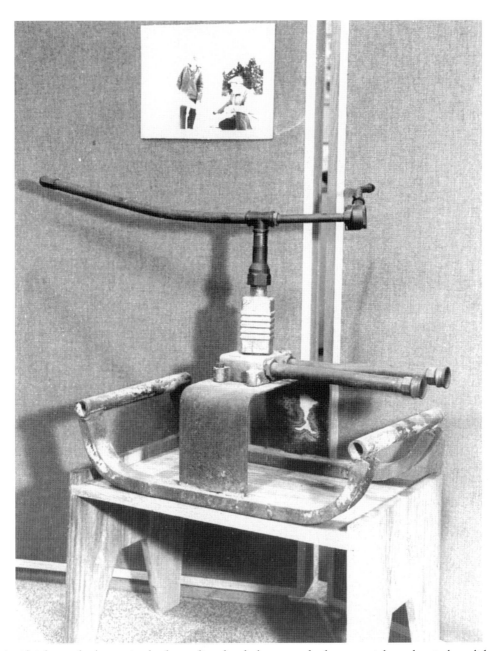

Artificial snow had come in the form of ice shards, borax, and other materials used on indoor slides and jumps before World War II. In Connecticut, at least two other experimenters were working at the same time as the Tropianos of Lexington, who accidentally left one of their fruit tree spray guns on during a frosty night and were surprised to find a pile of snow the next morning. Their Larchmont Engineering Company's first production model now can be viewed at the New England Ski Museum. Water and compressed air were fed into the sprinkler head. For the 1951–1952 season, Frank Carbone's Jericho Hill in Marlborough was the first area in the state to install snowmaking. The small area closed in 1995. (Courtesy New England Ski Museum.)

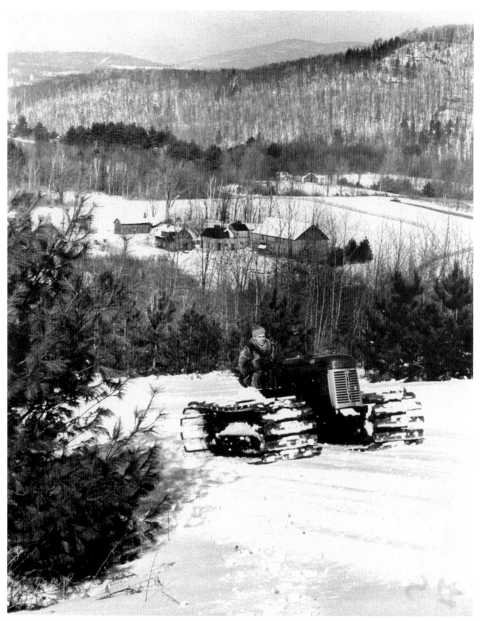

The ubiquitous snowcat was developed from the Weasel, an over-the-snow World War II vehicle. For larger areas, the machine became the trail maker, smoother, and groomer. The snowcat was the workhorse for the mountain in the 1950s, seen here with its fancy fur-coated driver at Bousquet's in 1952. Tucker, Pisten Bully, Thiokol, and other manufacturers produced varieties of snow-grooming machines. Indeed there is now snow called "machine groomed." Today area operators have many choices: the Piste Basher from France or the 18,542-pound Camoplast BR-35, and for cross-country tracks, the Trail Tenderizer. These huge machines can groom many acres. In one well-heeled area, using two shifts, 18 machines can groom 542 acres of skiing terrain per night. This perfect grooming comes at a cost—and the price of a day's skiing continues to rise. (Courtesy Paul Bousquet.)

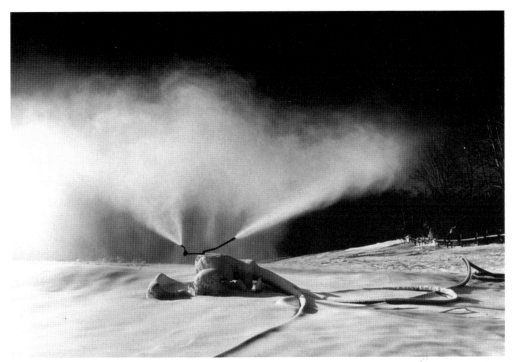

For all who find the snowmakers' noise, moist snow on goggles, and snaking pipes on a trail an interference with nature and natural skiing, think again. This Larchmont snow gun aesthetically sprays a carpet of pristine whiteness for their enjoyment in the late 1950s. (Courtesy Paul Bousquet.)

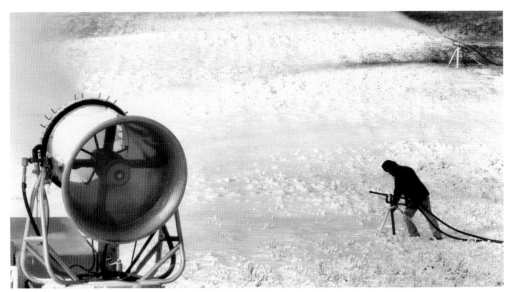

Mount Tom's conventional "homemade" guns seem antique as they are being replaced by a large, airless fan jet. The elimination of costly compressed air was the main advantage of the fan jet guns; however, they required electricity to turn the fan. Today tower guns from Natick's Snow Economics can lay a foot of snow on 400 acres in 48 hours. (Courtesy Cal Conniff.)

Old and modern are exhibited side by side by John Mohanna and Paul Bousquet at the 1971 Hartford ski trade show. Larchmont's first sprinkler, using many normal plumbing parts, contrasts with the Hedco cannon, in which water is atomized through tiny nozzles and blown out by the fan. Presently, Hedco's Super D can cover just over two acres with a foot of snow in 12 hours using 400 gallons of water a minute. (Courtesy Paul Bousquet.)

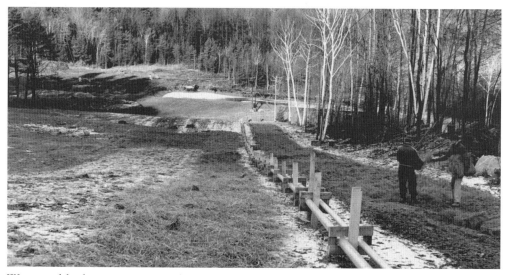

Water and high-pressure air pipelines were anchored on the side of the trail at Bousquet's in 1957. Before computers, the mix of air and water was often tested by the operator standing under the falling snow. If the snow felt like pellets and bounced off his jacket, it was dry; if it stuck, it was wet. Adjustments were needed at different elevations. Computers now regulate the mix. (Courtesy Paul Bousquet.)

SKIING GOES HIGH TECH

Gone are the days of man and animal muscle for building lifts. Vast amounts of capital are needed to upgrade a ski area. Bousquet's new lift towers are placed quickly and efficiently by helicopter. This method is considered environmentally sound as it eliminates the need for work roads on the mountains. Bousquet's now has two chairlifts and retains a number of rope tows. (Courtesy Paul Bousquet.)

Up until 1969, the Massachusetts Institute of Technology's wind tunnel was used exclusively for aviation studies. It then broadened its use for engineering and architectural problem solving. Tests have been run on racing bicycles, Olympic rowing sculls, and Olympic ski gear. In 1977, a U.S. team member tests his downhill position for drag in a 50-mile-per-hour wind. (Courtesy New England Ski Museum.)

Bousquet's, like many areas, provided for spectacular skiing. This hotdogger does a spread eagle off a lip that has been specially constructed. Terrain parks and half-pipes for snowboarders, mogul fields for bump skiers, and the ultra-smooth groomed trails for the aging are all part of the operators' attempts to keep skiers coming. (Courtesy Paul Bousquet.)

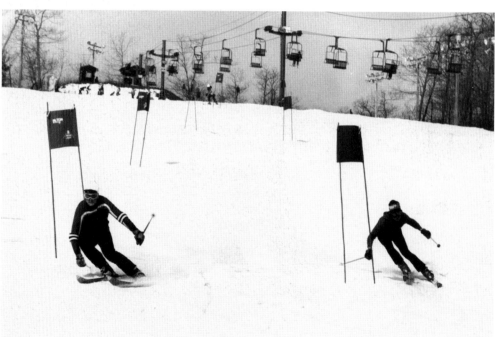

Nearly every ski area had a racing program. Nashoba Valley's program brought to the fore Pam Fletcher, whose six national titles were capped with a 1986 gold in World Cup competition. A new attraction was the head-to-head duel slalom races here at Mount Tom. Competitors had one run on each of the courses, and the combined times produced a winner. (Courtesy Cal Conniff.)

9

CAST OF CHARACTERS

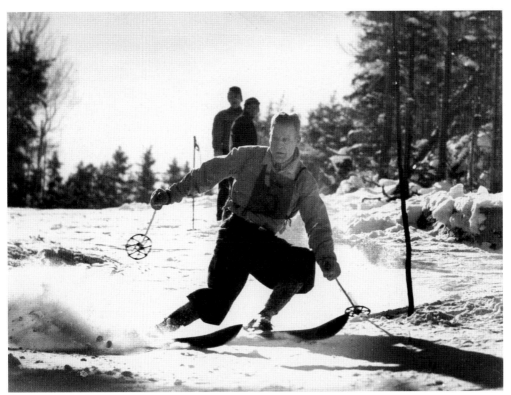

Leading light of Boston's Ski Club Hochgebirge, Alec Bright was known for his cavalier attitude toward skiing. Seen here doing his "hockey stop" as a means of slowing down on the course, he was a member of the U.S. team for the FIS competition in 1935 and the 1936 Olympic Games in Germany. (Courtesy New England Ski Museum.)

Otto Schniebs demonstrates the crouch technique of the Arlberg method of skiing in 1928–1929. Boston's AMC hired Schniebs as a dry land instructor in December 1928. He was also involved with the Harvard Mountaineering Society as ski mentor. That winter, he accompanied the AMC on club excursions. Members felt that their preparations really paid off as they could enjoy "lunging, crouching, jumping, and hip swinging." The "diagonal lunge" was for uphill work (herring boning), and the "telemark incognito" was only permitted when all Arlberg swings had been mastered. Schniebs also wrote an article in the *Boston Evening Transcript* and, once he had become better known, was in demand as an instructor. He was hired to coach at Dartmouth. He had become the "pied piper" of New England skiers. (Courtesy New England Ski Museum.)

Bart Hendricks was a charter member of the Mount Greylock Ski Club in 1932 and was partly responsible for obtaining CCC labor to cut the Thunderbolt trail. After the war, he founded the Jiminy Peak Mountain Resort in Hancock, which opened in 1948. With his Haselblad camera, he photographed the 1930s and 1940s, providing a wonderful record of skiing in the Berkshires. (Courtesy Cal Conniff.)

Founder and first president of the National Ski Areas Association and a 10th Mountain veteran, Dave Judson and his wife, Hooker, opened Otis Ridge in 1946. The area included two portable rope tows enjoyed by 150 kids coming for vacation ski camps. In 1960, ice-crushed snow was replaced by a Larchmont system. A Pomalift was installed in 1956, and a homemade J-bar was added. Touring trails were cut in 1975. (Courtesy New England Ski Museum.)

Ruth Brown was the grand lady of western Massachusetts skiing. In the 1940s and 1950s, she and her husband, Stan, introduced thousands to the sport through the Carlisle Hardware ski shop. With lots of hard work and the help of many friends, the two created the Berkshire Snow Basin Ski Area in West Cummington in the 1970s. When Stan died, Ruth continued to run the ski area for many years. (Courtesy Cal Conniff.)

A real character of New England skiing, Joe Dodge of Manchester forsook the family furniture company to become the best known of the AMC's hut men. This portrait is by Dwight Shepler, respected American ski artist in the 1930s, who was born in Everett and went to Williams College, where he took up skiing. A highly regarded war artist during World War II, he also became president of the Guild of Boston Artists. (Courtesy New England Ski Museum.)

CAST OF CHARACTERS

This 1938 profile of Roger Langley, housed in the archives of the New England Ski Museum, is one of a series by C. S. Hauschka showcasing prominent skiers of the 1930s. Langley served as a master at Eaglebrook School and later president of both the United States Eastern Amateur Ski Association and the National Ski Association of America. He participated in many ski developments, the ski patrol and ski troops being two of the most important. (Courtesy New England Ski Museum.)

One of the few women photojournalists at the time, Christine Reid of Brookline had contacts across the United States, Canada, and Europe. She published frequently in the Boston papers in addition to writing articles in such magazines as *Appalachia* and the *American Ski Annual.* Her photographic archive is one of the New England Ski Museum's treasures. Reid is pictured here in 1938. (Courtesy New England Ski Museum.)

George "Doc" Maynard was a legendary proponent of Berkshire skiing going back to 1932. A charter member of the Mount Greylock Ski Club, he also managed Jiminy Peak and oversaw its expansion in the 1950s. He was honored by having the Doc Maynard Center named after him. He was also a well-known race official. As an engineer, Maynard delighted in designing and building ski jumps. (Courtesy Cal Conniff.)

Ralph Townsend, a 10th Mountain veteran, won the U.S. Nordic Championships in 1947 and 1949 and represented the United States at the St. Moritz Winter Olympics in the Nordic Combined in 1948. He coached skiing at Williams College for 22 years and supervised the school's Outing Club. He was inducted into the U.S. National Ski Hall of Fame in 1975. (Courtesy Cal Conniff.)

CAST OF CHARACTERS

Ski area operators with early snowmaking systems were always trying to develop a snow gun that would produce more snow at a lower cost. Brian Fairbanks, president of Jiminy Peak in Hancock, is seen here in the mid-1970s with one of his own inventions. Fairbanks also acquired Brodie in 1999, allowing for condominium building and time shares at a time when real estate was driving the ski business. (Courtesy Cal Conniff.)

Lowell Thomas, whose books, articles, and especially his silver-timbred radio voice made him an icon for adventure in the 1920s and 1930s, loved to ski. He broadcast his shows from ski areas all over the country. Thomas (left) is seen here with Shaun Tucker, a supervisor of Bousquet's Ski School, in 1972. (Courtesy Paul Bousquet.)

Government officials from Teddy Roosevelt on were taking an interest in skiing both personally and, increasingly in the postwar years, politically, for its fiscal advantages for the local region and state. Sen. Edward Muskie from Maine came to the 1958 convention of the Eastern Amateur Ski Association and is flanked here by two of the most influential personages, Roger Langley (left) and Alec Bright (right). (Courtesy New England Ski Museum.)

One of the pleasant functions of newly elected governor Leverett Saltonstall was to congratulate E. H. Ted Hunter, member of the 1936 Olympic team, whose spectacular run on the Thunderbolt trail won him the 1939 Massachusetts Downhill Championship. The following week, he broke his left thigh in the Eastern Championships. (Courtesy New England Ski Museum.)

CAST OF CHARACTERS

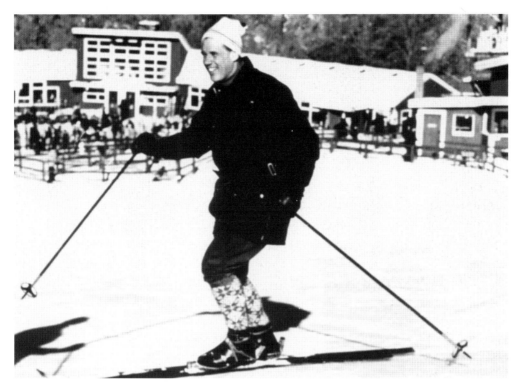

Francis W. Sargent, governor of Massachusetts from 1969 to 1975, was a veteran of the 10th Mountain Division who remained an avid skier. Although he would occasionally venture into the White Mountains, he made a point of skiing at his home state's skiing areas every season. (Courtesy New England Ski Museum.)

Taking a break from his Washington duties, Sen. Edward Kennedy heads up the mountain in 1956 with Paul Bousquet (left) as guide and companion. Like nearly everyone else in the Kennedy family, the senator was an accomplished skier who frequented Massachusetts ski areas when time allowed. (Courtesy Paul Bousquet.)

Astronaut and future Ohio senator John Glenn and his son take a lesson in 1962 from Jules Eberhard, Mount Tom's ski school director. It was the first time the astronaut had been on skis. A fast learner, Glenn would later join the Kennedy clan in Sun Valley. (Courtesy Cal Conniff.)

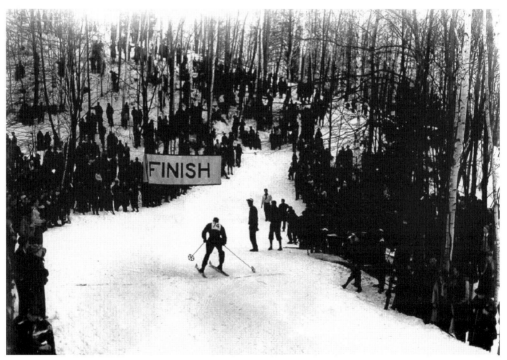

So ends the run through this brief pictorial history of skiing in Massachusetts. As they used to say in the 1930s, "Ski Heil!" (Courtesy New England Ski Museum.)

CAST OF CHARACTERS

BIBLIOGRAPHY

Allen, E. John B. "Millions of Flakes of Fun in Massachusetts: Boston and the Development of Skiing 1870–1940." *Sports in Massachusetts: Historical Essays*, edited by Ronald Story, 69–95. Westfield, MA: Institute of Massachusetts Studies, 1991.

Appalachia

Boston Herald

Boston Evening Transcript

Berkshire Eagle

Drinker, Pem, Chairman. *Ski Club Hochgebirge, 1931–1981.* North Adams, MA: SC Hochgebirge, 1981.

Hendricks, Bartlett. "Ski Heil to the Berkshires." *American Ski Annual* (1935): 111–120.

Hitchcock, John. "Leif, Odd and the Dovre Saga." *Ski Area Management* (Spring 1965): 169–171.

———. "Bousquet Is Where Lighting All Began." *Ski Area Management* IX, 2 (Spring 1970): 56–57.

North Adams Transcript

Purple Mountain Majesty. Documentary film. Directed by Blair Mahar. 1999; Hoosac Valley High School, Adams, MA.

Sanders, Charles. *The Boys of Winter: Life and Death in the U.S. Ski Troops during the Second World War.* Boulder, CO: University of Colorado Press, 2005.

Ski Bulletin

ACROSS AMERICA, PEOPLE ARE DISCOVERING SOMETHING WONDERFUL. *THEIR HERITAGE.*

Arcadia Publishing is the leading local history publisher in the United States. With more than 3,000 titles in print and hundreds of new titles released every year, Arcadia has extensive specialized experience chronicling the history of communities and celebrating America's hidden stories, bringing to life the people, places, and events from the past. To discover the history of other communities across the nation, please visit:

www.arcadiapublishing.com

Customized search tools allow you to find regional history books about the town where you grew up, the cities where your friends and family live, the town where your parents met, or even that retirement spot you've been dreaming about.